SUSSEX INDUSTRIAL HERITAGE

HERITAGE

Colin Tyson

AMBERLEY

Front cover: High Salvington Mill near Worthing was built in 1750 and is believed to be the oldest mill still standing in Sussex.
Back cover: Brickwork, Goldstone Pumping Station.

All photographs are by the author, unless otherwise stated. Thanks are due to Phil Barnes, Martin Snow and David Vaughan for their help with research and photography.

First published 2018

Amberley Publishing
The Hill, Stroud
Gloucestershire, GL5 4EP

www.amberleybooks.com

ISBN 978 1 4456 7626 5 (print)
ISBN 978 1 4456 7627 2 (ebook)

Typesetting and Origination by Amberley Publishing.
Printed in Great Britain.

Contents

Introduction

From the windmill at Selsey in the west to the old shipping warehouses of Rye in the east, this book attempts to act as a guide to the best of the surviving sites of industrial interest that are either openly accessible to the public (even if limited) or can be viewed from public roads or footpaths. It is my hope that you will be sufficiently enthused by the book's contents to explore some of these sites for yourself as you discover a little more about how our ancestors made their living. Please respect the privacy of occupiers of privately owned buildings, and please do not trespass.

Sussex was never in the vanguard of industrial progress, and after early iron production in the Sussex Weald, things settled down to largely servicing the needs of agriculture. Long-forgotten industries came and went, such as the production of gunpowder (particularly around the Battle area), shipbuilding, sand mines, the Wealden glass industry at places such as Chiddingfold, Kirdford and Wisborough Green, and Wealden clays were used for 'Sussex Ware', a type of brown earthenware made from the late eighteenth to the early twentieth century. There are virtually no traces now on the ground from these types of industries.

The coming of the railway, with the main London to Brighton line as its central spine, brought new economic activity and the growth of the seaside resort. With cheaper goods being brought in from elsewhere it was the death of the old craft industries, but goods from Sussex continued to be taken to our ports to be exported to the near Continent.

With Britain in the twenty-first century being firmly in a post-industrial phase, the links with the working lives of our ancestors become increasingly distant. Unfortunately, even in our enlightened times, sites of industrial interest can be demolished at very short notice. Traces of many of our past industries have been lost, particularly in urban areas where former industrial sites make obvious choices for 'brownfield' development by authorities under pressure to find available land for housing, retail or service industries.

The internet has become a valuable resource to the industrial archaeologist, although a degree of caution needs to be exercised over accuracy in some cases. I have found the National Library of Scotland's Georeferenced maps website of great help in showing a selection of Ordnance Survey maps from the 1890s onwards, displayed side by side with modern satellite mapping (www.maps.nls.uk/geo). Referencing these maps will help you to discover places for yourselves that once played their part in the working environment of Sussex.

Chapter 1

Brewing and Malting

The brewing of beer is as old as time immemorial. The addition of malted barley to hot water, adding hops and then fermenting by adding yeast is a tried and tested formula from a time when beer was safer to drink than the water.

Sussex once boasted over 150 breweries, but their number declined due to takeovers and mergers as the industry contracted. Much brewing was centred in the past on Brighton, with the likes of Rock Ales and the Kemp Town Brewery, followed by Tamplins into the 1960s. Many public houses survive with their original ownership branding, especially in the Sussex coastal towns, and the North Laine conservation area in Brighton is particularly well-served with such examples. Several malthouses survive where barley was once spread on the floor and germinated prior to drying in kilns.

Oast houses, designed for drying hops as part of the brewing process, with their distinctive round brick towers and coned and vented roofs, are more associated with the hop-growing areas of Kent, yet there are plenty of examples still to be found in the east of the county – in the most part, extended into desirable homes. Indeed, hop varieties such as Sussex Fuggles are still grown commercially.

Arundel, Tarrant Street
Lambert & Norris Ltd's Eagle Brewery was registered in 1897 and acquired by Friary, Holroyd & Henly's Breweries Ltd (with eighty-one houses) in 1918. It was then used as a depot until 1955. Offices remain on the south side of the street, but the yard was given to housing in 2015. TQ 016070.

Brighton, London Road
Malthouse for Henry Longhurst's Amber Brewery, the brewery being opposite and demolished in the early 1900s for road widening where the fire station now sits. The business was taken over by Kemp Town Brewery. Frontage was added when the building became the Duke of York cinema, which claims to be the oldest cinema in continuous use in Britain. TQ 312055.

Brighton, South Road, Preston
A single-storey malthouse that was built to serve the adjacent Preston Brewery and used up until the 1880s. TQ 302064.

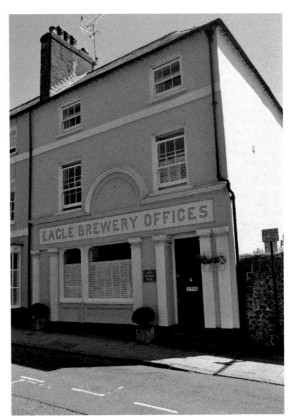

Right: The offices of Lambert & Norris Ltd's Eagle Brewery in Tarrant Street, Arundel, which was first registered in 1897.

Below: The malthouse for Henry Longhurst's Amber Brewery on London Road, Brighton. The fancy frontage is not original and was added when the building became the Duke of York cinema, which claims to be the oldest cinema in continuous use in Britain.

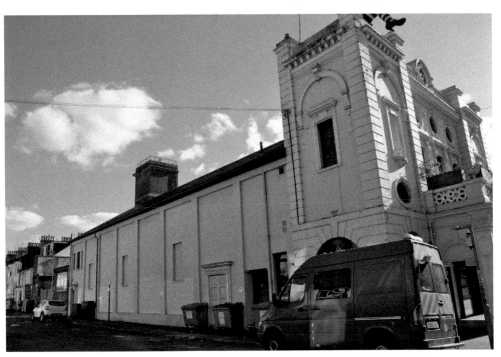

The malthouse in South Street, Preston, Brighton, with a single roof vent. It was built for the adjacent and now demolished Preston Brewery.

Cooksbridge, Lewes Road
A three-storey brick and flint malthouse built in the eighteenth century for the Cooksbridge Brewery. Malting ceased in 1912. TQ 400132.

East Grinstead, Station Road
A malthouse built for John Dashwood's Hope Brewery, which was situated opposite the malthouse on the site now occupied by a fire station. The brick building is now the premises of the Royal British Legion. TQ 390385.

Lewes, Bear Yard
A Grade II listed three-storey malthouse for the Monk Brewery that was situated beside the Ouse. It was converted to private dwellings in 1994. TQ 420101.

Lewes, Bridge Wharf
Harveys Brewery, situated adjacent to the River Ouse and accessed from Cliffe High Street, celebrated its 200th anniversary in 1990. John Harvey was supplying customers with wine and port from 1793 and was brewing in Bear Yard by around 1820, acquiring the current site in 1838. Should modern electric power fail, Harveys can call on two steam engines situated in the original engine room. The original engine here is a rare bayonet frame horizontal engine by Pontiflex & Wood of Shoe Lane, London, installed in 1881, while a second engine was acquired when Beard & Co. of Lewes ceased brewing in 1984 to concentrate on wholesaling. This is a unique surviving example

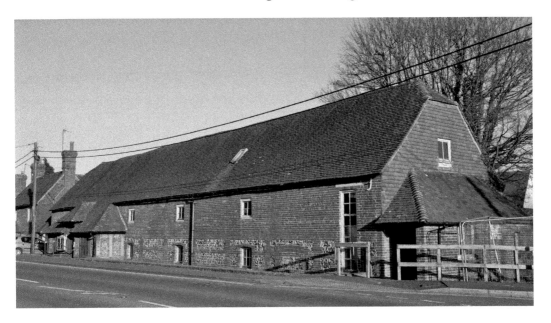

Cooksbridge malthouse on the east side of the A275. The brewery was on the west side of the road. Malting ceased in 1912 and the building was used as the village hall from 1919 to 2007.

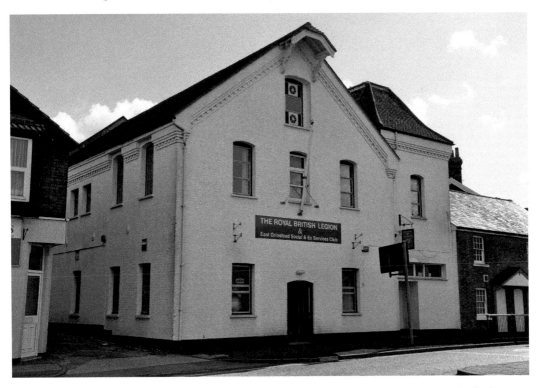

The malthouse for John Dashwood's Hope Brewery in Station Road, East Grinstead. The brewery was opposite, on the site now occupied by the fire station.

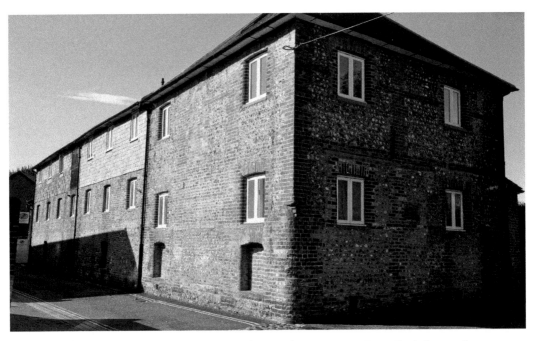

A Grade II listed three-storey malthouse for the Monk Brewery in Bear Yard, Lewes. It was converted to residential use in 1994.

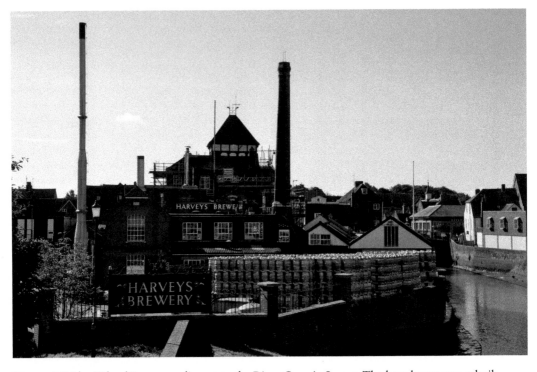

Harveys' Bridge Wharf Brewery, adjacent to the River Ouse in Lewes. The brewhouse was rebuilt in 1880 but the original fermenting room remains.

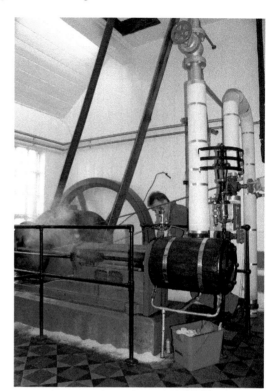

Right: The Pontiflex & Wood steam engine, installed at Harveys Brewery in 1881. The engines at Harveys are maintained by members of the Sussex Steam Engine Club. (David Vaughan)

Below: The rare Lewes-built Alfred Shaw single-cylinder vertical engine used to be at Beards Brewery, and is now installed at Harveys Brewery, Lewes. (David Vaughan)

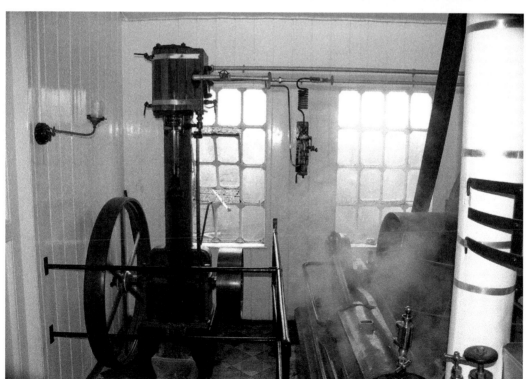

of a single-cylinder vertical engine, locally built in Western Road, Lewes, by Alfred Shaw, who traded between 1882 and 1887. Brewhouse rebuilt in 1881 but the original fermenting room remains. TQ 420103.

Lewes, Castle Precincts
Built by J. Langford for his Castle Brewery, the building was later bought by E. Beard & Son to supply its nearby Star Lane Brewery. It has now been converted to office units. TQ 414102.

Lewes, Cluney Street
A malthouse built to supply Verralls' Southover Brewery, which was opposite the Swan public house and established in the 1780s. Converted to private dwellings, it retains a working roof-mounted ventilator for the drying fires at its eastern end. The Swan pub retains a glazed front door panel declaring 'Southover Ales & Stout'. TQ 411096.

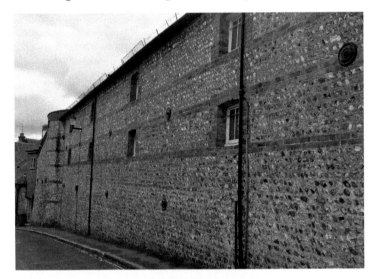

The Castle Brewery malthouse on Castle Precincts, Lewes, was built from local materials. It was later owned by E. Beard & Son, which ceased brewing in 1959.

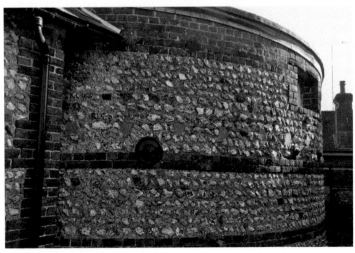

This rounded section at Castle Brewery's malthouse contained the drying room, where fires would direct warm air through the damp barley on the drying floors.

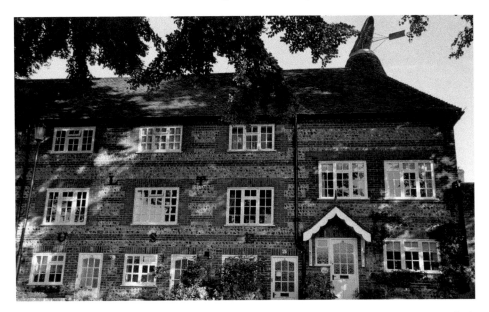

The malthouse on Cluney Street, Lewes, was built to supply Verralls' Southover Brewery, which was established in the 1780s. Note the ventilator on the right-hand side for the drying fires.

Lewes, Fisher Street
Beard's Star Lane Brewery was worked from the 1740s and was Beard's Brewery from 1845, who also purchased the nearby Castle Brewery's malthouse. George Beard died in 1958 and brewing ceased in 1959, with its beers then being brewed by Harveys. The building has now been converted to small business units but retains its malted barley sack hoist on the west side. TQ 414102.

Lewes, Thomas Street
Southdown Brewery. Owned twenty-eight tied houses at its peak in 1888. Purchased in 1895 by Thomas and Augustus Manning along with Dashwood's Brewery in East Grinstead, it was renamed Southdown & East Grinstead Brewery. Both breweries were then purchased by Tamplins in 1920. The nineteenth-century classic style counting house is now converted to office accommodation. TQ 421105.

Lindfield, High Street
The chimney, cottages and sheds from the Durrant family's brewery are found to the rear of The Stand Up Inn. Brewing ceased in the 1920s. TQ 346254.

Portslade, South Street
J. Dudney, Sons & Co. Brewery. Both tower brewery and chimney survive, with inscription at base of chimney reading 'D & S 1881'. Founded in 1849 and acquired by Kemp Town Brewery in 1919, it was then taken over in 1921 by Smithers & Sons Ltd of Brighton, who brewed here until 1928. The brewery plant was offered for auction in January 1930. Part of the brewery was operated as the Portslade Brewery Co., brewer of table beer around 1934, and was closed by 1938. The last owners were Le Carbone (GB) Ltd, and the premises remain intact but disused. TQ 255063.

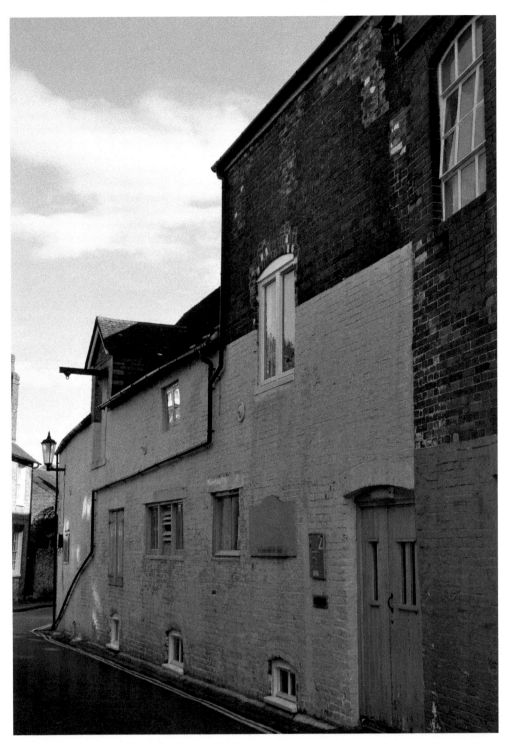

Beard & Son's Star Lane Brewery on Fisher Street, Lewes. Beard's beers were produced by Harveys from 1959, following the death of George Beard in 1958. Note the extruding sack hoist.

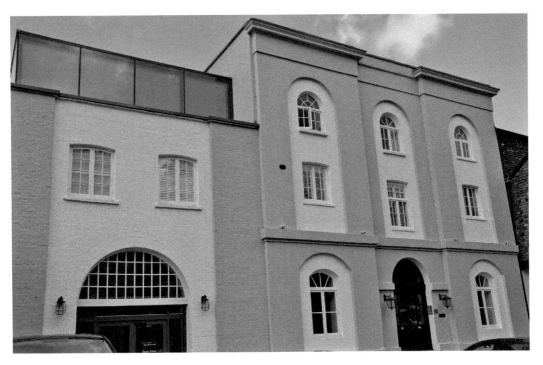

The nineteenth-century former counting house of the Southdown Brewery on Thomas Street, Lewes. It was purchased with Dashwood's Brewery of East Grinstead in 1895 to become the Southdown & East Grinstead Brewery.

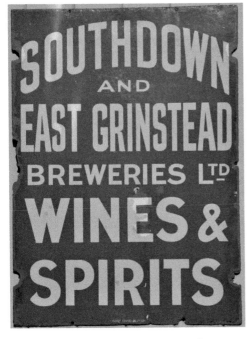
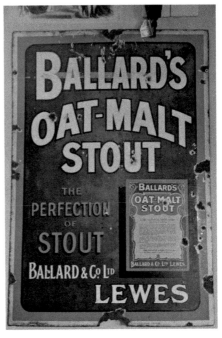

Enamel signs from long-gone Sussex breweries.

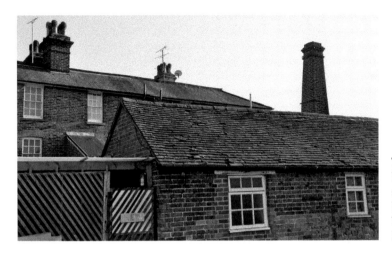

The Durrant family's brewery chimney, sheds and cottage behind their Stand Up Inn premises on Lindfield High Street.

Worthing, Warwick Road

Chapman's Brewery; a tower brewery with a cold liquor tank in situ at the top. Harry Chapman ceased brewing here and at Burgess Hill when the company was sold to the Kemp Town Brewery, Brighton. The adjacent Egremont Hotel (1836), remodelled by Kemp Town Brewery, boasts several surviving decorative features and fascias from the former brewery. TQ 153026.

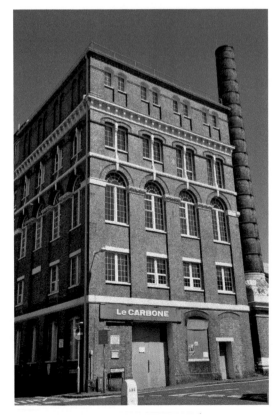

The tower brewery and chimney of J. Dudney, Sons & Co. on South Street, Portslade.

16

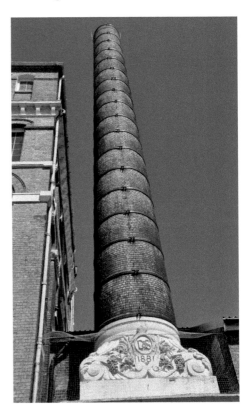

Dudney's chimney base detail – 'D & S 1881',
entwined with barley stalks and hops.

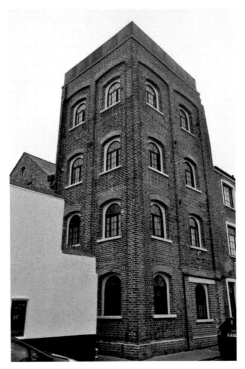

Chapman's tower brewery on Warwick Road,
Worthing, with the cold liquor tank in situ.
It was later owned by Brighton's Kemp Town
Brewery, which remodelled the adjacent licensed
premises of the Egremont Hotel.

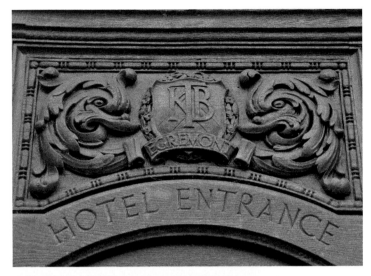

Carved 'KTB'
woodwork of the
Kemp Town Brewery
at the entrance to
the Egremont Hotel,
Worthing.

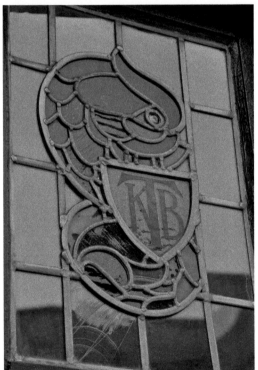

Above left: The Dolphin trademark of the Kemp Town Brewery, Egremont Hotel.

Above right: A building more associated with neighbouring Kent and its hopfields than Sussex; nonetheless, there are several oast houses, which were once used for drying hops and are now exclusively extended residential properties, to be found in East Sussex towards the Kent border. This typical Sussex oast is at Bodle Street Green.

Chapter 2

Brickmaking

Virtually every part of Sussex that isn't chalk downland yields material under the layer of topsoil that is suitable for making bricks and tiles. Geologically, the Hastings Beds of the High Weald produce the best strata of mineral content for brickmaking and Wadhurst Clay, Weald Clay, Tunbridge Wells Sand and Ashdown Sand all have properties useful for brickmaking or providing sand for the moulds.

The Romans brought brickmaking to Britain and evidence of Roman brick kilns in Sussex is documented. Bricks were then being used again in Sussex from the early fourteenth century onwards. With timber being so plentiful across the Wealden forests, bricks were not the first construction material of choice, and Herstmonceux Castle (1440s) appears to be the earliest building in Sussex to be completely of brick. Even in timber buildings bricks were often used for chimneys and fireplaces and, nearer the coast, stone and flint for walls and foundations were used as cheaper alternatives or where clay deposits were not found.

Brickmaking came back in fashion when Brighton and other coastal resorts started to develop, resulting in a surge in demand that the interior rural brickyards couldn't satisfy. Thus came the introduction of larger manufacturing concerns, such as that at Wick, near Littlehampton.

The 1898 Ordnance Survey 6-inch maps marked 180 brickyards in the county, and little evidence remains of the majority of these. By 1945 just fifty-three firms advertised in *Kelly's Directory*.

Without heavy industry to fall on, bricks were mainly produced to supply the housing market. This meant that they could be produced in a cost-effective way where quality and strength were not prime considerations.

Sussex can lay claim to the last UK brickyard to burn handmade bricks in a wood-fired kiln – on the Ashburnham estate, which ceased production in 1968.

Rural brickfields were simply abandoned and returned to agricultural use as brickmakers went from site to site.

Today, brickmaking on a large scale is pretty much confined to the Midlands, but those brickmaking sites that do survive in Sussex are now subsidiaries of national and international concerns, such as Ibstock and Redland, and both the machinery employed and the buildings that house them are far removed from those of even thirty years ago.

We are fortunate that there are excellent displays depicting Sussex brickmaking, both at Amberley Museum & Heritage Centre and the Weald & Downland Museum at Singleton.

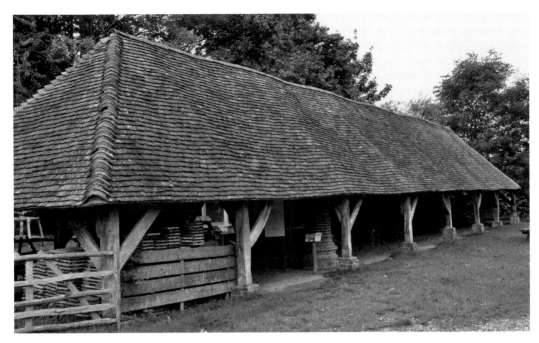

This typical rural brickworks drying shed of 1733 was sited just over the Sussex border in Petersfield, Hampshire, but was dismantled in 1979 and re-erected at the Weald & Downland Museum at Singleton in 1990. The shed was used to stack freshly moulded 'green' bricks and tiles to dry prior to being fired.

This narrow gauge railway brick wagon used to be at Crowborough Brickworks, but is now situated on the Great Bush Railway at Tinkers Park, Hadlow Down. It is typical of a type used to transport bricks to a drying area before they were fired.

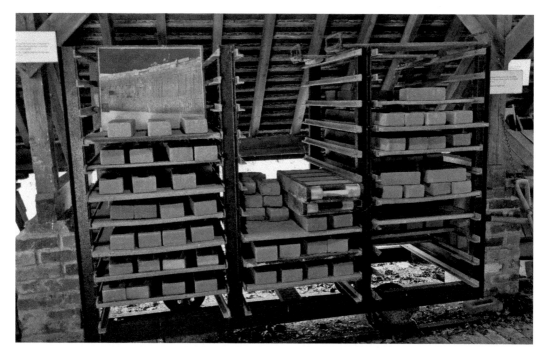

A tall brick wagon at Amberley Museum.

Manufactured in the 1930s, this 2-foot gauge Motor Rail locomotive (No. 1 *Aminal*) is under overhaul at the Great Bush Railway. New to the East Sussex River Board, it passed to the Ludlay Brick & Tile Co. Ltd at their Berwick brickyard in the late 1950s/early 1960s and was purchased for preservation when the brickworks closed in 1969.

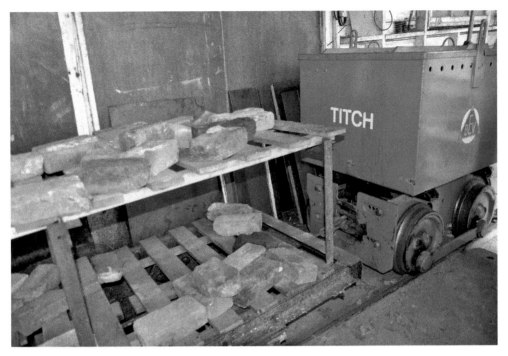

The most modern ex-brickworks locomotive at the Great Bush Railway is this 0-4-0BE Wingrove & Rogers No. M7535 of 1972 (No. 24 *Titch*). It was supplied new to Crowborough Brickworks and arrived for preservation in 1981, having sat at Crowborough for a year after closure in 1980.

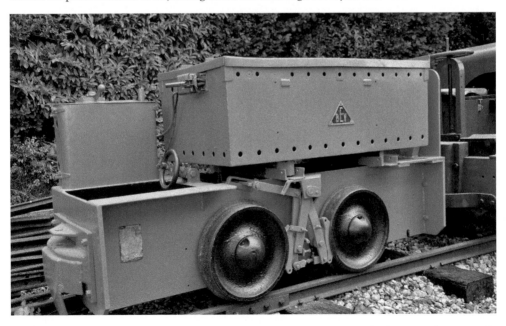

4WBE Wingrove & Rogers No. 5033 of 1953 (No. 22 *Lama*) was supplied new to the Sussex & Dorking United Brick Co. at their works near Hambledon, Surrey, and was transferred to Crowborough Brickworks in 1972. It is now at the Great Bush Railway.

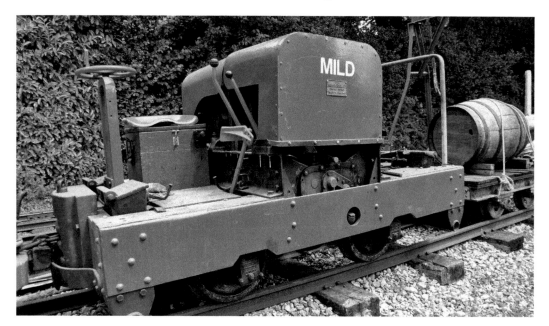

4WDM Motor Rail No. 8687 of 1941 (No. 4 *Mild*) was new to the War Department, moving then to Redland Bricks in Hampshire before being transferred to Crowborough in 1971.

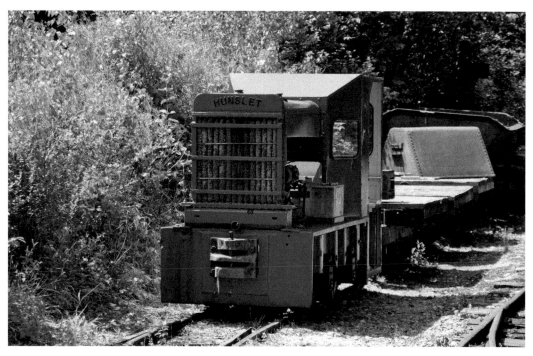

A 1941 Hudson Hunslet 2-foot gauge locomotive, which was adapted to pass beneath a sand hopper at its former location of Thakeham Tile Works near Storrington. The loco would shuttle to the hoppers with two skip wagons, each carrying 1½ tons of sand. It is now preserved close to its former home at Amberley Museum.

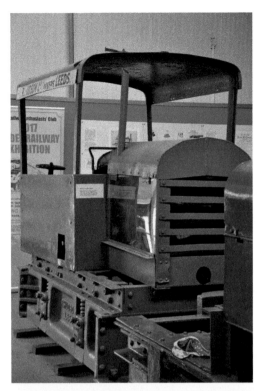

Left: This 2-foot 6-inch gauge Robert Hudson of Leeds petrol/paraffin tractor, No. 4591 of 1932, boasts a Fordson tractor engine. Belonging at first to the Midhurst Whites Ltd brickworks, Midhurst, it is now at Amberley Museum.

Below: A Robert Hudson of Leeds skip wagon chassis that was used for permanent way duties at the Great Bush Railway.

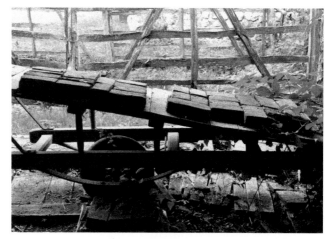

Newly moulded bricks were manually carried via a hack barrow to be dried. This example is preserved at Singleton.

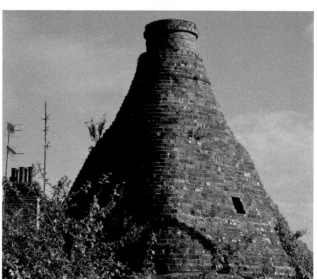

Believed to be the last survivor of an updraught cupola type of pottery kiln in Sussex, this is seen in the garden of Kiln Cottage on the east side of the A275, just north of Piddinghoe. Dating from the early nineteenth century, the brick-built cone tapers toward the top, housing a central firing chamber flue. It was rebuilt from a semi-derelict state by members of the Sussex Industrial Archaeology Group in 1981. TQ 433032.

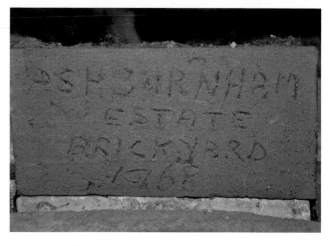

A brick from the final firing at the last brickyard to burn handmade bricks in a wood-fired kiln, which occurred on the Ashburnham estate, which ceased production only in 1968.

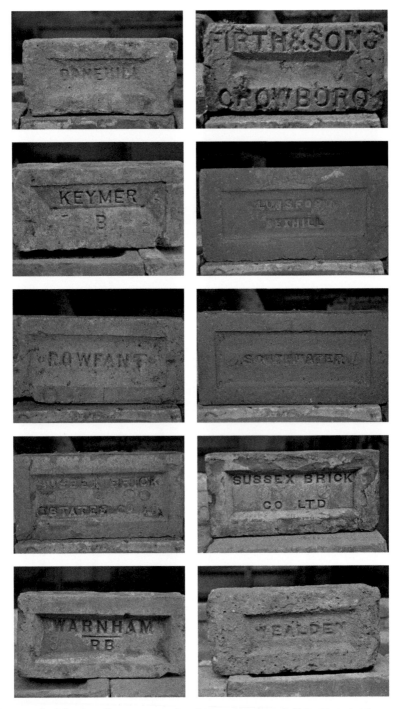

Sussex frog-marked bricks. The practice of making a 'frog', or indentation, in the surface of a brick started in the late eighteenth century and could take the form of a name, initial or logo. Examples are bricks from Danehill, Crowborough, Keymer, Bexhill, Rowfant, Southwater, Sussex Brick, Sussex Brick & Estates, Warnham and Wealden (Horsham area).

Chapter 3

Chalk Quarries, Lime and Cement

One doesn't have to travel too far within the Sussex Downland to see the bright white tell-tale scars of worked-out chalk quarrying, usually with horizontal lines visible where chalk was extracted in chunks at a time. Workers would loosen the face with gunpowder and dig the chalk out with pick and shovel before barrowing it to on-site kilns for burning night and day to produce lime.

Lime was transported to wheat-growing farms in the Weald following the discovery of its use in fertiliser, building materials in the manufacture of mortar and cement and for roadmaking. The burning of lime was common to illuminate early public buildings, such as theatres (hence the term 'in the limelight'). With most of the Sussex chalk downland now within the designated boundaries of the South Downs National Park (operational from 2011), there are now only two extraction licences in force for chalk, and just a handful for sand extraction.

Amberley Lime Kilns
Amberley Museum & Heritage Centre is set in a 36-acre former chalk quarry and lime works, with its associated buildings and kilns having been preserved. The Pepper family of Littlehampton moved to Amberley in around 1874, where John Pepper and son Thomas established a business as lime and cement merchants. New kilns were built and descendants of the Pepper family worked the site until the late 1960s. Nos 1 and 2 kilns, the former office and bagging shed are conserved, as are the splendid De Witt kilns of 1905, now a Scheduled Ancient Monument. Belgian manufacturer Hippolyte De Witt supplied kilns to increase lime production, based on a design of kiln used to burn high-quality bricks. Their use was not a complete success, but they are believed to be the only surviving example of the type. TQ 028118.

Duncton Lime Kilns
A series of three lime kilns set into the chalk downs south of Duncton village. Built of brick and flint with double brick arches of mid-nineteenth-century build, they were sited adjacent to the chalk pits. The kilns can be viewed from a public bridleway heading into trees due south from the village on the A285, at the foot of Duncton Hill. SU 961162.

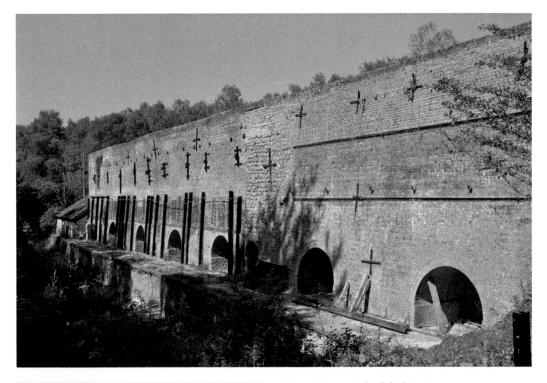

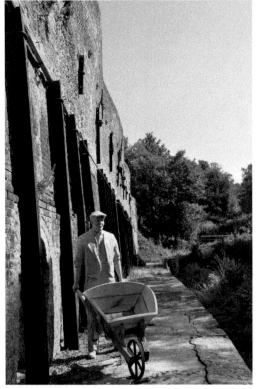

Above: Now a Scheduled Ancient Monument, the eighteen-chamber De Witt lime kilns preserved at Amberley, which at one time was one of the largest lime-burning sites in Sussex. Closed in 1960, they are now part of Amberley Museum.

Left: Looking east along the De Witt kilns, the figure of a worker gives an idea of scale.

Above: The De Witt kilns were rail-served and wagons were on site to distribute lime and other building materials produced by Pepper & Sons to the adjacent main railway line from 1863, as well as for coal coming in.

Right: Chalk was burned day and night to produce lime.

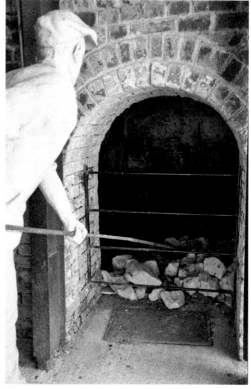

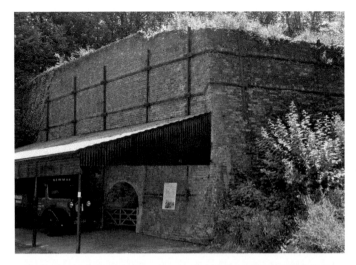

The earlier No. 2 lime kilns at Amberley, now part of Amberley Museum, were built at the beginning of the twentieth century to replace the No. 1 kiln.

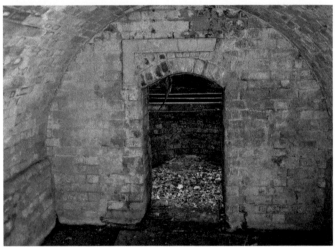

The bottle-shaped chambers of No. 2 kilns are 23 feet deep.

A grate was made at the bottom of each chamber with iron bars placed over the three iron rails, with bricks on top with gaps for the air to flow. Wood and straw were placed on top and the chamber was then filled with coal and chalk alternately. The burnt lime was drawn off at the bottom of the kilns.

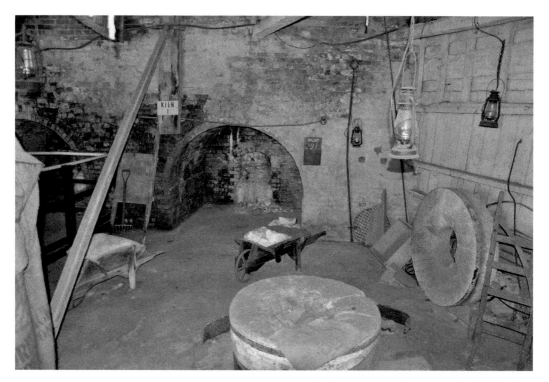

Above: A reconstruction of No. 1 kiln at Amberley Museum.

Right: A brick and flint-built lime kiln set into the South Downs at the foot of Duncton Hill which can be viewed from the adjacent public bridleway.

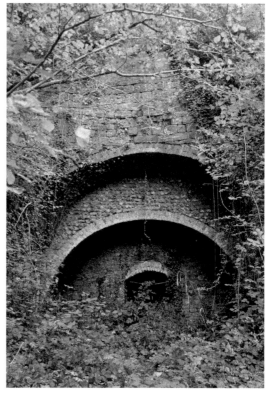

Glynde Quarry

The quarry is shown on old maps as Balcombe Chalk Pit, although it is some 20 miles away from the village of that name. Glynde was opened in 1834 and was in operation until lime burning finally ceased around 1970. A tramway used to run in a cutting under the road and emerge by the station platform. Works buildings survive on the abandoned site. TQ 458086.

Offham Chalk Quarry

The transportation of chalk and lime from Offham Pit was initially made by horse and cart down to barges at the wharf below, which linked to the River Ouse for onward shipment. Improvement to the operation came when pit owner George Shiffner commissioned engineer William Jessop to speed things up, and in 1809 Sussex received its first 'railway' in the shape of a funicular wagonway. It took loaded wagons under the road that is now the A275, attached to cables and rolled on rails through a 22-metre double tunnel. Stone for 'sleepers' was quarried at Wych Cross and loaded at Sheffield Park to travel to the site by barge on the Upper Ouse Navigation. The weight of the full trucks travelling down one tunnel pulled the empty ones back up the other. It was disused by 1890, but the preserved brick-lined tunnel entrances can be viewed from the car park of the former Chalk Pit Inn, which is now an Indian restaurant, and the exits can be viewed down towards the river. TQ 400116.

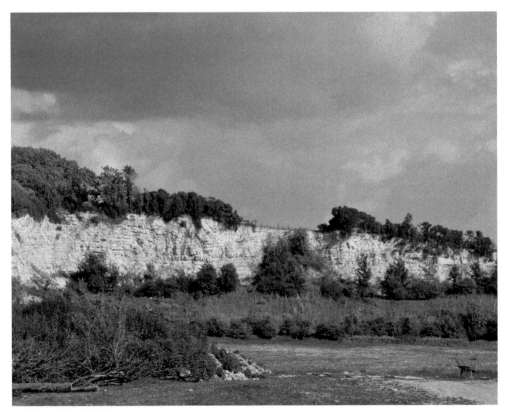

The abandoned chalk quarry at Glynde, which ceased to operate around 1970.

A fine Sussex tiled-roof building among the disused offices at Glynde Quarry.

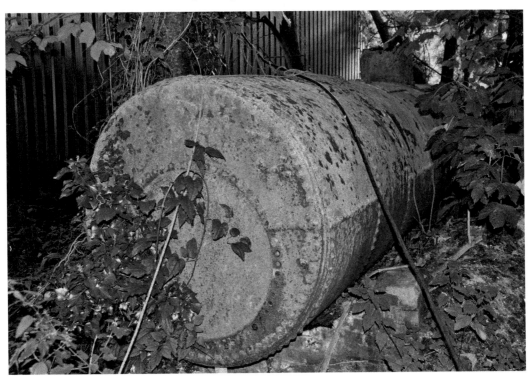

An abandoned iron boiler at Glynde Quarry.

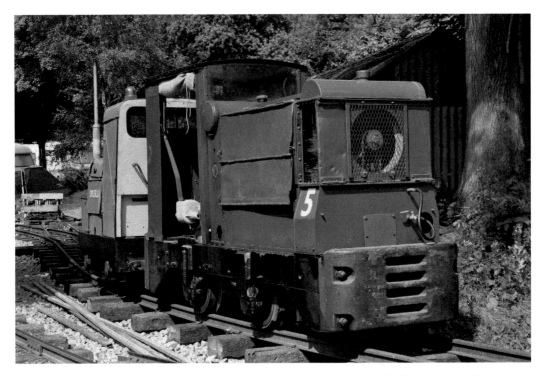

Ruston Hornsby No. 5 *Alpha* was recovered from the Associated Portland Cement works at Rodmell and is now at the Great Bush Railway at Hadlow Down.

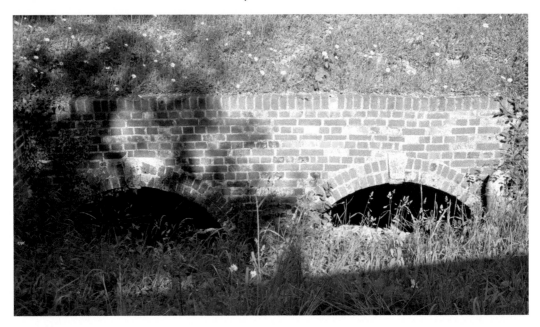

The higher end of two well-preserved brick-lined tunnels that once carried a tramway from Offham Chalk Pit down underneath the A275 to a wharf near the River Ouse below, effectively becoming the first 'railway' in Sussex.

The Chalk Pit Inn at Offham, though much altered and extended, originally housed the offices of Offham Chalk Pit. The premises are now an Indian restaurant.

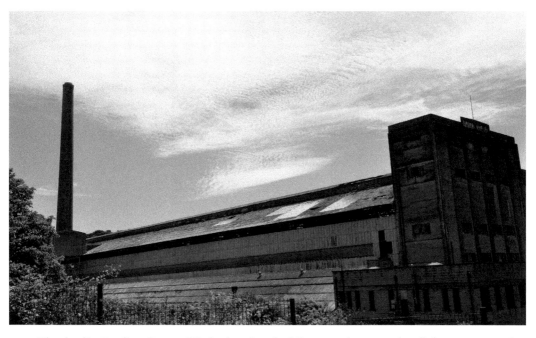

The derelict Beeding Cement Works, housing the kilns, a coal store and a clinker room, together with the 200-foot chimney.

Washington Lime Kilns

Four kilns built in around 1839 of brick and chalk by local farmers Herbert and Thomas Floate. Production ceased about 1930, but the quarry site continued to expand. The kilns were located south of the village, on the old road (Washington Bostal), and from there via a track running east. TQ 120123.

Beeding Cement Works

Built on the site of a former chalk quarry in the Victorian period, the Beeding Cement Co. was formed in 1882. It was bought out a few years later by the Sussex Portland Cement Co. of Newhaven, then in 1912 by British Portland Cement Manufacturers. Under the 'Blue Circle' brand the plant was rebuilt by 1951 using modern Vickers Armstrong rotary kilns housed in buildings made of pre-cast concrete blocks and a covered conveyor system that once carried cement across the A283. The works were rail-served by what was one of the last three freight-only lines left in Sussex when it closed in 1981. Finally closing a decade later, in 1991, the derelict works still form a landmark on the A283 road from Shoreham to Lower Beeding. TQ 199086.

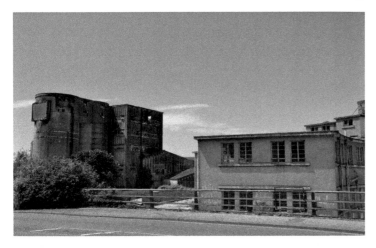

The packing areas and storage silos at Beeding Cement Works, seen on the west side of the A283. A covered conveyor system once crossed the road here.

The terraces of Beeding Cement workers' cottages at Dacre Gardens.

Chapter 4

Wealden Iron

The Wealden landscape of Sussex, and to a lesser extent that of the adjoining counties of Surrey and Kent, was the foremost ironmaking centre of Great Britain – both in the Roman occupation of AD 43–400 and again in the sixteenth century.

The Romans produced iron on an industrial scale and traded both within Britannia and in adjacent provinces of its Empire. It was not until the Middle Ages that the industry began to expand again.

The second major period for Wealden iron began at the end of the fifteenth century, now with the benefits of blast furnace technology introduced from Belgium and then Normandy, thence to the Weald of south-east England. Immigrant ironmasters worked for the Crown during the sixteenth century on gun-founding and landowners built up a considerable trade for items such as iron grave slabs, firebacks for domestic properties, ploughshares and agricultural tools, wheel rims and even heavy cannon.

The ore on which the Wealden blast furnace industry was based was clay ironstone from the Wealden Beds, transported into the areas by the rivers of Cretaceous times. Iron is also present in clays of Jurassic age and much older red sandstones.

Iron-ore workings were clustered on the High Weald east of West Hoathly, where Ashdown Beds and Wadhurst Clay ore was worked; the Horsham-Crawley area at the western end of the High Weald (the lower part of Weald Clay and iron ore from Upper Tunbridge Wells sand) and the western end of the Weald (Pallingham, Lurgashall areas) utilising clay ironstone from near the top of Weald Clay.

The Weald's iron deposits lie close to the surface, and so were easily extracted by open cast mining. The great Sussex forests of Ashdown, St Leonard's, Tilgate and Worth were important smelting areas, managed by controlled coppicing to conserve timber for charcoal production. The writing on the wall for the Sussex industry came with the advent of the giant coke-fired blast furnaces in 1709, and ironmaking was left to rivals in the Midlands and Scotland. With the Weald now reverted to forestry and agricultural use, the only evidence of a once-proud 'pre-industrial age' industry are the considerable number of surviving hammer ponds and their associated bays, tell-tale waste (slag) from the smelting process and examples of ironwork, which can be seen in museums such as the Iron Room at Anne of Cleves House in Lewes, and Ifield Mill, Crawley. Wadhurst church contains several cast iron grave memorials.

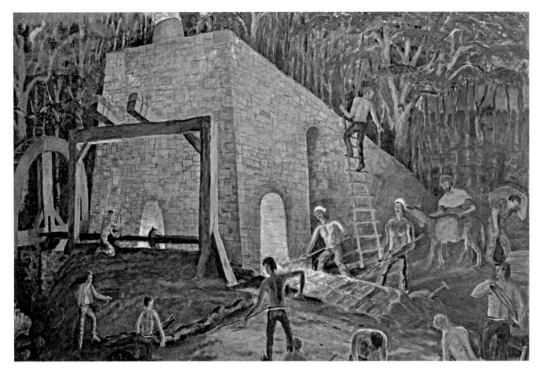

A painting that captures the heat and hard work involved in the forging of Wealden Iron in the sixteenth century.

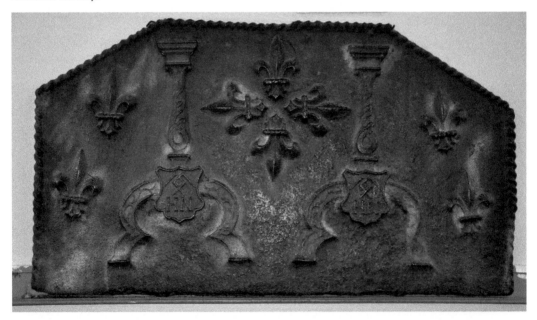

A Wealden iron fireback made up of several moulds of fleur-de-lis and the initials 'HN', believed to be for Henry Nevill, Baron Bergavenny, of Holmbush Farm, Helllingly. Henry owned ironworks near Frant and Mayfield and was one of the most important Sussex ironmasters in the 1580s.

The cast iron slab that formed the roof of the chamber below a blast furnace hearth, believed to originate from Brede or Beckley iron furnace.

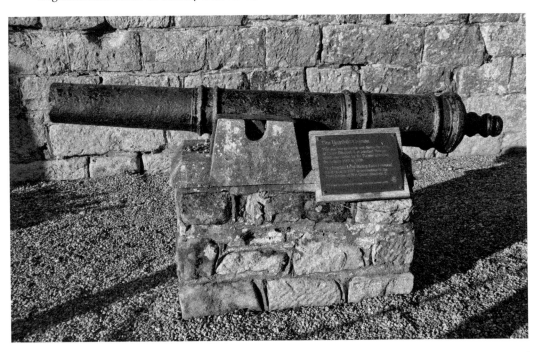

The 'Mayfield cannon', on display in Mayfield High Street and probably cast during the reign of Queen Elizabeth I at Mayfield Furnace.

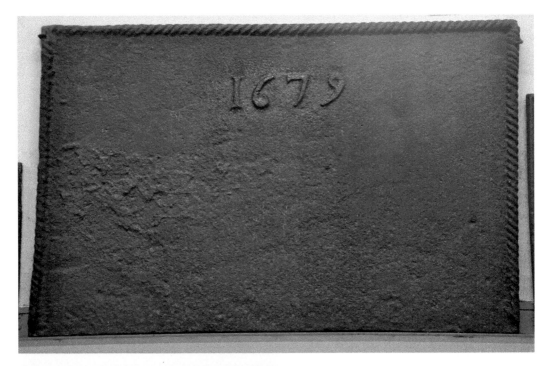

Above: Lengths of stiffened rope have been used for a border for this fireback from the Anchor Hotel, Eastbourne, dated 1679.

Left: There is now no trace of John Every's Phoenix Ironworks in Lewes, although the name lives on in Phoenix Causeway (the last highway in Lewes to cross the Ouse), as the foundry on the surviving platform canopy and subway railings on the former Lewes & East Grinstead Railway, and on road drainage ironwork.

Cast iron replica of a 'bow bells' milestone from Lower Dicker as part of a series on the Uckfield to Langney turnpike. Some also included the Pelham Buckle as a mark of respect to the famous Sussex landowners on all mileposts situated on their land.

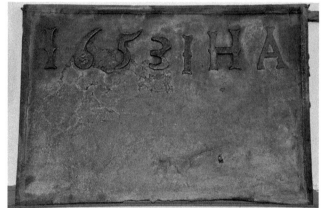

The initials on this fireback, I. H. A. (or J. H. A.), could have belonged to the ironmaster himself, the landlord or the customer. Crudely carved individual moulds were used for the date and inscription.

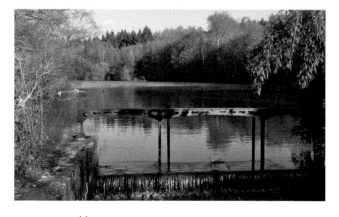

Several examples of forge hammer ponds still survive in East and West Sussex as a reminder of the Wealden Iron industry. This example is at Furner's [Furnace] Green near Danehill, with a spillway in the middle of the pond bay.

Chapter 5

Watermills

While windmills can be easily spotted in their generally exposed positions, watermills tend to be in wooded valleys and on private land. The selection listed here can either be viewed from the highway or are open to visitors at certain times.

Burton Mill
The present stone-built mill building, built on the foundations of an earlier forge or fulling mill, dates from around 1790. The mill once had a waterwheel on each side of the building, which were replaced by turbines – one to drive a dynamo to provide power to Burton Park House and one to drive a circular saw. Situated on Burton Park Road, off A285, south of Petworth, it is only open to visitors on National Mills Weekend (May). SU 979180.

Cobbs Mill, Sayers Common
The mill was rebuilt in the nineteenth century with machinery by W. Cooper of Henfield, including an overshot waterwheel. The mill contains a Tangye 40 hp gas engine, No. 1233, from around 1904, which was fitted in 1908 and installed second-hand by J. W. Holloway & Sons, engineers of Shoreham-by-Sea. Cobbs Mill is only open via private invitation. TQ 274189.

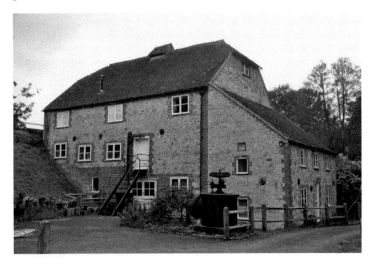

Burton Mill, near Petworth, dates from around 1790.

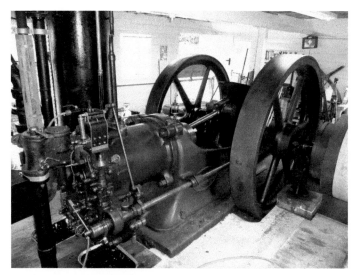

Cobbs Mill, Sayers Common, housing Tangye 40 hp gas engine No. 1233 of around 1904, which was fitted second-hand in 1908. (Tim Keenan)

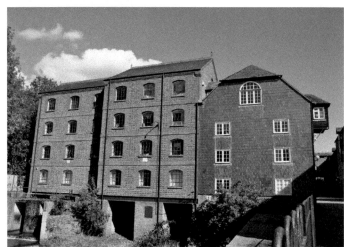

Hempstead Mill, Uckfield; a corn mill built in the nineteenth century and now given over to commercial use.

Hempstead Mill, Uckfield
A large corn mill on the River Uck of brick, timber frame and weatherboarding. With an 1894 date stone, the mill was extended in 1922. Most recently used to generate electricity, the breastshot wheel was removed and the building has now been converted to offices. TQ 483217.

Horsebridge Mill, Horsebridge
A large commercial corn mill of brick with gabled roof, owned by McDougalls from 1921 to 1969. Now derelict with internal machinery removed and decaying undershot wheel by Upfield of Catsfield. TQ 581113.

Ifield Mill, Crawley
Situated on the bay of a hammer pond that provided power for a sixteenth-century iron forge until 1642, when the furnaces at Bewbush closed down. A corn mill was built on

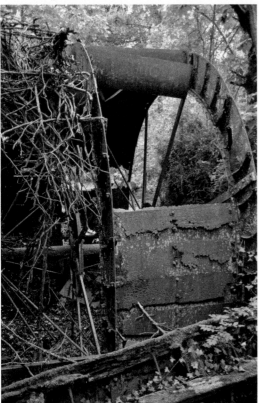

Above: The derelict and gutted Horsebridge Mill.

Left: The undershot wheel at Horsebridge, supplied by John Upfield & Sons of Catsfield, Battle, and now in a state of decay.

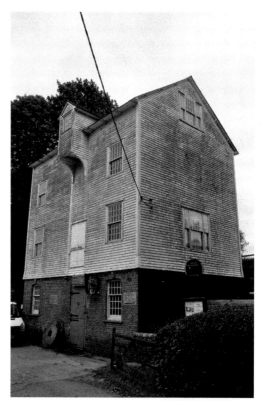

Right: Ifield Mill, rebuilt in 1817 and closed in the 1920s, was restored in 1974 by Crawley Museum Society volunteers.

Below: The waterwheel at Ifield Mill, with a penstock by Cooper of Henfield.

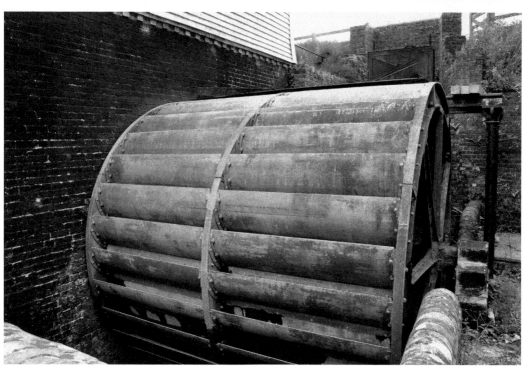

the site and was working by 1660 under miller William Garton. A four-storey brick and Sussex weatherboard structure with an overshot wheel, it was rebuilt in 1817 and closed in the early 1920s. The mill was restored from derelict by Crawley Museum Society volunteers in 1974 and the waterwheel was reconditioned via a Heritage Lottery Fund grant in 2008. It is open the third Sunday in the month. TQ 245364.

Isfield Mill, Isfield

A large nineteenth-century five-storey corn mill with a turbine, situated on the River Uck. Of brick with a gabled slate roof, the mill has now been converted to private dwellings. The ghost of a sign for Dickson & Church, Millers, can still be seen on the brickwork. TQ 448181.

Lurgashall Mill (Singleton)

A seventeenth-century stone-built corn mill that lasted until the 1930s. Dismantled from Lurgashall in 1973, it was re-erected in 1977 at the Weald & Downland Museum at Singleton. The mill contains an overshot iron wheel and largely boasts wooden machinery. It can be seen working daily, offering stone-ground flour for sale. SU 875128.

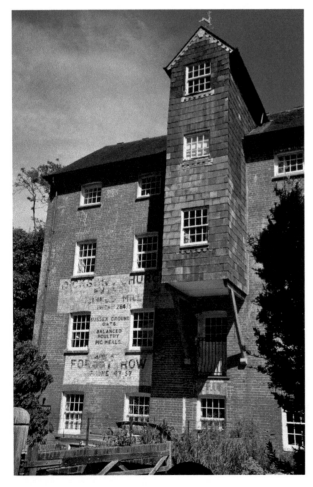

'Sussex Ground Oats and Balanced Poultry Pig Meals' – the five-storey corn mill at Isfield used to be the premises of Dickson & Church, Millers. It is now private dwellings.

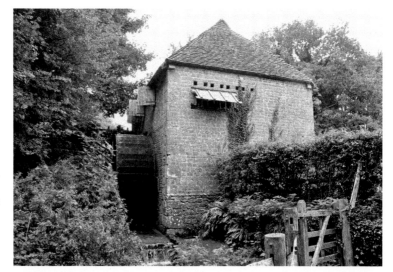

The former Lurgashall Mill with an overshot wheel was re-erected at the Weald & Downland Museum in 1977 and can be seen working daily.

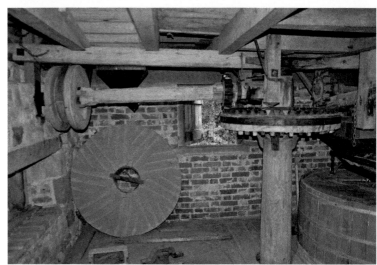

The interior of Lurgashall Mill, working with mainly wooden machinery.

Michelham Priory Mill, Arlington
A surviving watermill from the mid-sixteenth century, but earlier mills are mentioned at Michelham from around 1260. Milling ceased in 1924 and the machinery was removed. It was restored in 1971 with an undershot wooden wheel, which was then replaced with a cast iron wheel by Janes of Wimborne in 1997. It is now owned by the Sussex Archaeology Society and is open daily from mid-February to mid-December. TQ 556093.

Park Mill, Batemans, Burwash
Situated on the River Dudwell in what is now the extended grounds of Batemans, a grand sandstone house that was built for a Sussex ironmaster, and was home of author Rudyard Kipling from 1902 until his death in 1936. It is now the property of the National Trust. The current timber-framed mill dates from the eighteenth century, and the main axle tree was replaced in early 2017. Adjacent to the mill stands a brick turbine

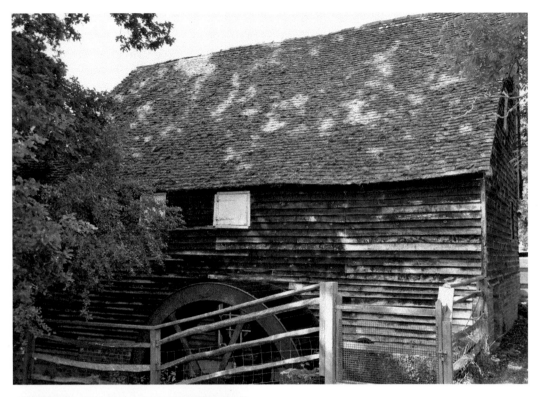

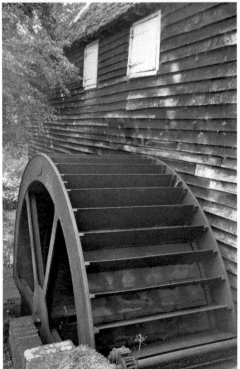

Above: Michelham Priory Mill, a timber-framed building on a brick base, was restored in 1971.

Left: Michelham's cast iron breast undershot waterwheel replaced a previous 1971-built wooden wheel in 1977. The original iron wheel housing by John Upfield & Sons of Catsfield is extant, and dated 1890.

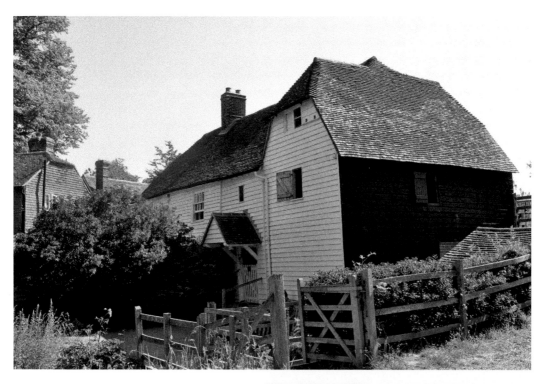

Above: The timber-framed Park Mill at Batemans, Burwash, was at one time the property of the author Rudyard Kipling.

Right: The waterwheel at Batemans is situated adjacent to a water turbine that was installed by Kipling to drive a dynamo to light his house.

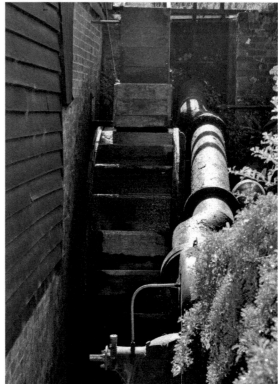

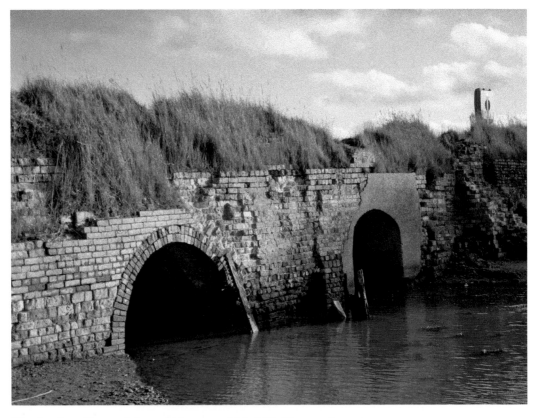

The derelict mill race sluice at Bishopstone Tide Mill. The area is now a nature reserve.

house, which was installed by Kipling to drive a dynamo to provide electric light for the house – one of the first domestic water turbine electric generators (*see Chapter 8*). The mill is open daily. TQ 670233.

Tide Mill, Bishopstone
Erected in 1761 as part of a village that contained the large mill and several workers' cottages, the mill ceased working around 1900 and remains now consist of footings and the derelict mill race sluice from the sea to the mill pond. It is now part of a popular nature reserve that contains a former railway station (latterly Bishopstone Beach Halt, closed 1942), the remains of a hospital, nurses' home and a base for experimental seaplanes. TQ 459002.

Woods Mill, Small Dole, Henfield
An eighteenth-century flour mill with an overshot wheel and a penstock dated 1854 by Neale & Cooper, millwrights of Henfield. The mill site, with adjacent ponds and woodlands, is the headquarters of the Sussex Wildlife Trust, and is open throughout the year. TQ 218137.

Woods Mill, Henfield, is now the headquarters of Sussex Wildlife Trust.

The iron penstock at Woods Mill by Neal & Cooper of Henfield, dated 1854.

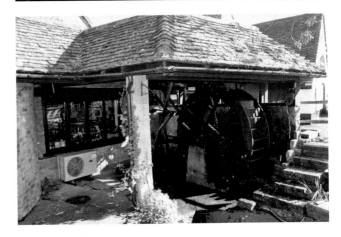

Dunnings Mill, East Grinstead, is now a pub and restaurant.

Chapter 6

Windmills

Harnessing the power of wind to turn stones, by which corn could be ground into meal to make bread to sustain the local population, was introduced to Britain from France in the twelfth century.

Sussex is blessed with some fine surviving examples of post mills, smock mills and tower mills, which once numbered well over 100. Around fifty have been lost completely over the centuries, while those remaining extant in anything like an original form, and are worth seeking out, are fewer still.

A post mill is of wooden construction, built around a centre post on which it pivots to face the wind direction.

A smock mill is a timber tower, usually of weatherboard, surmounted by a cap that rotates to bring the 'sweeps' (the Sussex term for a driving sail) into the wind. It is said to resemble a shepherd's smock.

A tower mill is usually constructed of brick or stone, again with a cap that is capable of being rotated to bring the sweeps into the wind.

Argos Hill
A white post mill on top of Argos Hill, near Mayfield. Built in 1835 and now Grade II listed, it ceased working commercially in 1923. A Trust was formed in 2010, leasing the mill from Wealden District Council, to raise funds for restoration. The mill's sweeps turned again in 2016 for the first time in over eighty years. It is open once a month from March to October – visit www.argoshillwindmill.org.uk for dates. TQ 571283.

Chailey
A white smock mill now devoid of most of its machinery, it has stood on this site since 1864. It was originally located at Highbrook, West Hoathly, in 1830, prior to moving to Newhaven to replace a mill that burnt down in 1844. The mill houses a museum of local artefacts and is found on Mill Lane, on the north side of the A272. It is open on the afternoon of the last Sunday of the month from April to September. TQ 387214.

Clayton, Jack and Jill
A unique pair of windmills, known as Jack and Jill. Jack is a black cement-faced tower mill with a white cap and fantail, built in 1866 and worked until 1907, and is only open by special arrangement. Jill is a white post mill with tailpole fantackle. It was

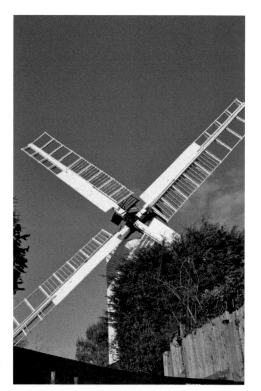

Argos Hill Mill, near Mayfield. Following restoration, the mill's sweeps turned in the wind in 2016 for the first time in over eighty years.

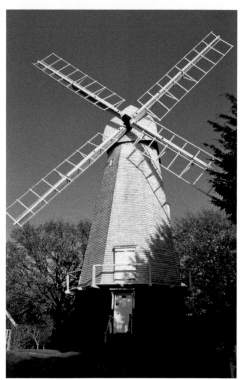

Chailey is the third location for this mill, which started life at Highbrook and moved to Newhaven before coming to Chailey in 1864.

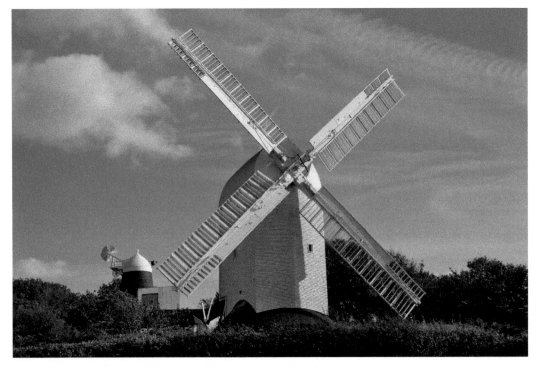

A famous Sussex downland landmark, the unique paired mills of Jack and Jill at Clayton. Jack is privately owned but Jill is open to visitors.

originally located in Brighton in 1821 before moving to Clayton around 1852, and also worked until 1907. The mill is open Sundays/Bank Holidays from May to September. TQ 303134.

High Salvington
A black post mill with a tailpole built around 1750 on an older mill site. Believed to be the oldest mill still standing in Sussex, it was restored in 1991. A renovated granary and windpump from Glynde chalk quarry are also present on site. The mill is situated at the top of Bost Hill, running west of the A24 north of Worthing, and is open for the afternoon of the first and third Sundays from April to September. TQ 121066.

Keymer (Oldland Mill)
A white post mill built in 1703 with a steam engine installed around 1870 beside the mill to provide auxiliary power. Abandoned in 1912, it became derelict, though with much machinery still intact. Restoration started in 1980 and a set of new sweeps were finished in 2007. It is open the first Sunday of each month. TQ 321163.

Lowfield Heath
A white post mill with a tailpole. It is technically a Surrey mill, on the southern edge of Gatwick Airport, but it spent thirteen years in Sussex under the boundary changes of 1974 before moving back into Surrey and a new site at Russ Hill, Charlwood, during 1987–89.

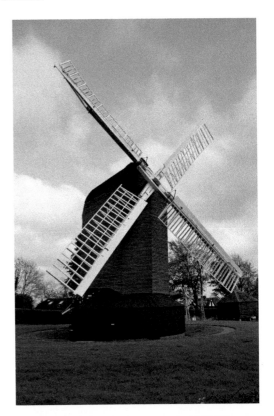

High Salvington Mill of 1750 is believed to be the oldest mill still standing in Sussex.

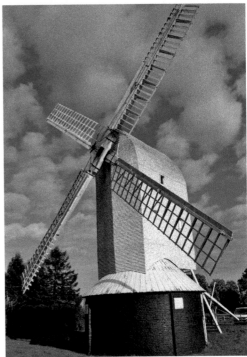

Lowfield Heath Mill – a structure that spent thirteen years in Sussex following the 1974 boundary changes and has now returned to Surrey with a move to Charlwood.

The grounds are open all year round for viewing, and the mill itself is open on the last Sunday in the month from April to August, as well as during the National Mills Weekend. TQ 235408.

Polegate (Ovenden's Mill)

A brick tower mill built in 1817 for Joseph Seymour of Blackboys and worked by wind until the Second World War. Known as Willingdon Windmill until 1939, it was purchased by Ephraim Ovenden, father of the last miller, Albert, in 1918, who finished working the mill by electric motor until commercial operation ceased in 1965. Albert Ovenden passed the mill to the Eastbourne & District Preservation Trust for £1,000. It is open Sundays/Bank Holidays from Easter to October. TQ 582041.

Rottingdean (Beacon Mill)

A black smock mill built in 1802 by Thomas Beard, which ground corn for the village until 1881. A Grade II listed landmark on the A259 coastal road, it was restored and maintained by the Rottingdean Preservation Society. The sweeps and stocks were replaced in 2003, with support from the Heritage Lottery Fund. It is open on selected Sundays in the summer. TQ 366025.

Selsey (Medmerry Mill)

A red brick tower mill built in 1805, worked until 1890, rebuilt in 1908, and worked until the 1920s. Now devoid of any machinery, it is found west of the village, opposite the entrance to West Sands Holiday Park. SZ 844934.

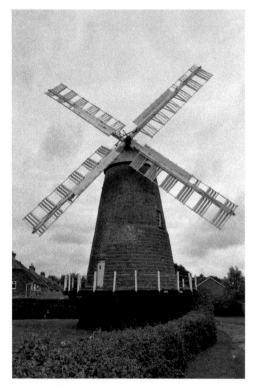

Polegate Mill was erected in 1817, and was known as Willingdon Mill until 1939. It is now surrounded by modern housing.

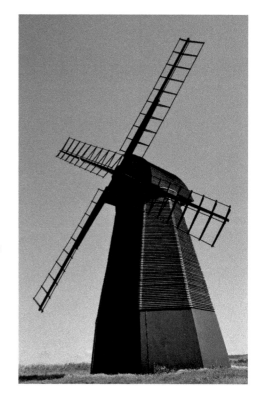

Right: A landmark on the South Coast Road east of Brighton, Rottingdean Mill of 1802 is maintained by a local preservation society, and restoration was supported by the Heritage Lottery fund.

Below left: Rye Mill is a privately owned white smock mill of 1820, which was reconstructed upwards from its brick base in 1932 following a fire. It has been a B&B guest house since 1984.

Below right: Selsey Mill, erected in 1805 and worked until the 1920s, is now devoid of machinery. It once featured an outside gallery, which was unique in Sussex.

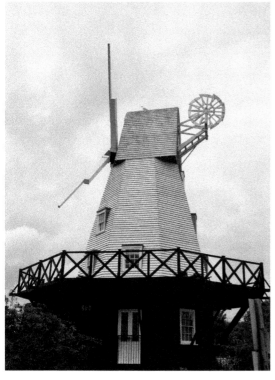

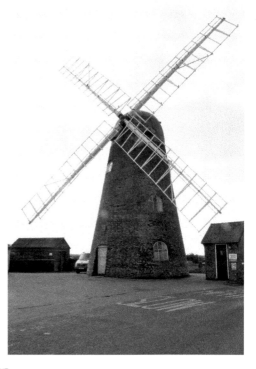

Shipley (Vincent's Mill)
A white smock mill built in 1879 by Grist & Steele of Horsham. Owned by writer and poet Hilaire Belloc in 1906, it was worked until 1926. The original machinery is in place, but the mill is privately owned and not currently open to visitors. TQ 143218.

Stone Cross
A white tower mill faced in cement, it was built in 1876 by Stephen Neve of Warbleton and worked until 1937. The mill was saved by the formation of the Stone Cross Mill Trust in 1995 and is Grade II listed, aided by the Sussex Mills Group and Wealden District Council. The mill retains all of its original machinery and is open on Sundays in the summer. TQ 619043.

West Blatchington
A black smock mill of unusual design with a flint and brick-built base through part of the existing farm barns. Built around 1820, it ceased to work in around 1897. Painted by Constable in 1825, the original machinery remains, along with items rescued from other Sussex mills. It is open Sundays/Bank Holidays from May to September. TQ 279068.

Westham Windpump
A hollow post pumping mill of nineteenth-century origin, the windpump was erected to pump water from the brick clay workings at Westham, near Pevensey. It was then removed and re-erected at the Weald & Downland Museum, Singleton. SU 875128.

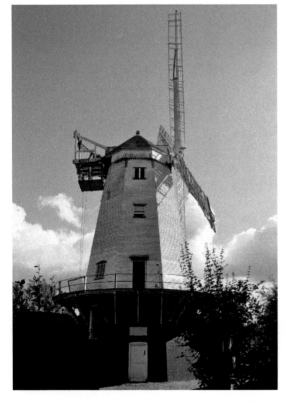

Shipley Windmill was once owned by the writer and poet Hilaire Belloc, but it is now privately owned and closed to the public.

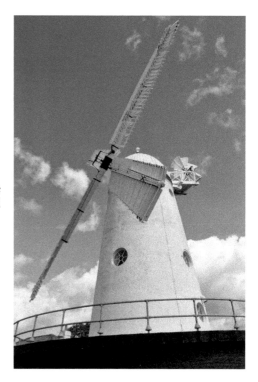

Right: Stone Cross Mill is one of only three tower mills in Sussex to have retained its original machinery.

Below left: West Blatchington Mill in Hove is unusual in that its flint and brick base was built through existing farm barns. The mill still houses its original machinery.

Below right: Erected to pump water from a brick clay works at Westham, this hollow post windpump was saved and re-erected at the Weald & Downland Museum.

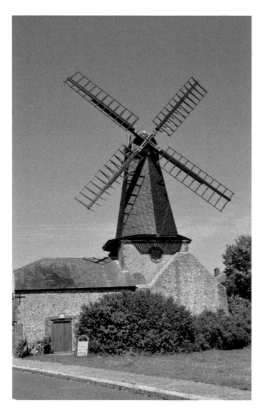

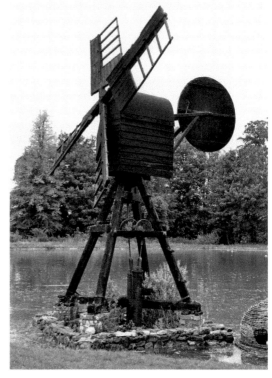

Windmill Hill

A white post mill and unique outer roundhouse, it was erected around 1814. It is the largest post mill in the country and the tallest post mill in Sussex. Restored in 2006 with help from a £557,000 Heritage Lottery grant, it is open most Sundays/Bank Holidays from Easter to mid-October. TQ 648122.

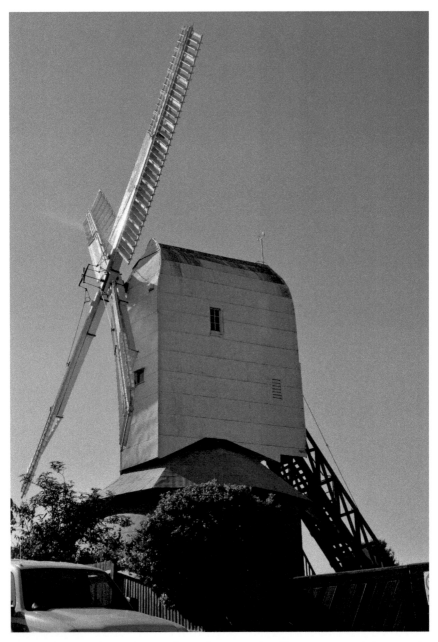

Windmill Hill Mill can claim to be the largest post mill in Britain, and the second tallest. It was restored in 2006.

Chapter 7

Animal Power

The use of animals for natural power is centuries old, the examples in Sussex being horse gins, where the horse was tethered to a pole attached to a gear shaft, and donkey wheels where a wheel is turned by a donkey or pony.

Arundel, Horse Gin
A twelve-sided building of vernacular construction that housed a horse-powered gin (short for 'engine'), which was located at James Penfold's Tortington Ironworks near Arundel and used by Penfold as a forge in later years. Believed to originally have been used to crush oil from flax seeds (linseed), the listed building was re-erected at Amberley Museum in the late 1980s. TQ 028118.

The horse gin at Arundel, used by Penfold's of Arundel to crush oil from flax seeds. It was dismantled and re-erected at Amberley Museum.

Brighton, Preston Park, Horse Gin

Housed in a roofless flint and brick building in a dilapidated condition and fenced off to the public, this gin can be viewed from the footpath near St Peter's Church in Preston. TQ 305065.

Brighton, Stanmer Park, Donkey Wheel

Stanmer Well House, rebuilt in 1838 at the same time as the new Stanmer church and situated in a corner of the church yard, houses a rare vertically mounted, 13-foot diameter donkey wheel, which was used by villagers to draw water from a well dug in the sixteenth century. Stanmer Park can also boast a horse gin, but the building now containing it stands within a gated residential development next to the house and is rarely open to visitors. TQ 336096.

Redford, Pugmill

A mid-nineteenth-century brick and stone structure dismantled in 1979 from Redford, near Midhurst, in which clay was prepared for brickmaking. Re-erected in 1980 at the Weald & Downland Museum, it houses a single-shaft pugmill that was rescued from an East Grinstead brickyard. SU 874128.

Saddlescombe, Donkey Wheel

Housed in a slate-roofed, wooden building on the National Trust estate near Brighton, the donkey wheel was used by the farm to draw water from a 50-metre well until the 1920s, when mains water came to the farm. TQ 273115.

The derelict and fenced-off horse gin building in Preston Park, Brighton.

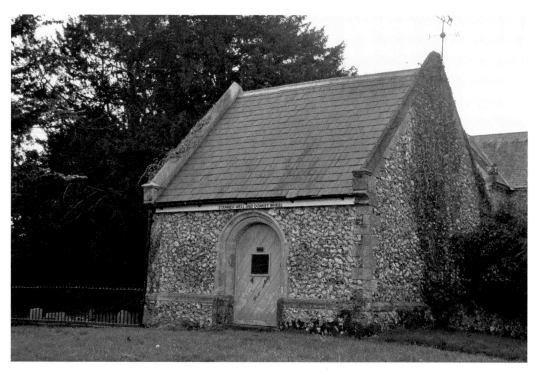

The well house, which houses a donkey wheel, in Stanmer Park, Brighton.

This uninteresting structure houses the horse gin at Stanmer Park, Brighton, but is within a private gated development and is closed to visitors.

This horse gin, with a single shaft, was rescued from Redford near Midhurst and re-erected at the Weald & Downland Museum.

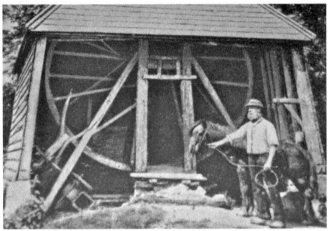

Saddlescombe Farm donkey wheel, with donkey 'Commodore Nut' ready for action. (National Trust)

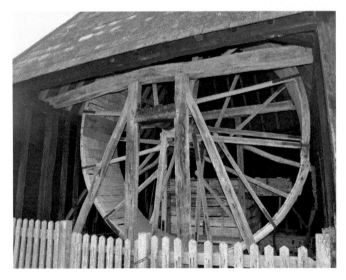

The well-preserved donkey wheel at Saddlescombe near Brighton.

Chapter 8

Public Utilities

Electricity

Brighton can lay claim to the oldest continuous supply of electricity in Sussex. Brighton resident Magnus Volk fitted his own home with electric lighting in 1880, and by 1884 had illuminated the Royal Pavilion ballroom and other council-owned properties in the town, such as the Corn Exchange, Library and the Dome. He then built Britain's first public electric railway on Brighton seafront in 1883, which is now operated and managed by the city council. Writer and poet Rudyard Kipling was also experimenting with electricity at his home at Batemans, Burwash – building a turbine at his estate's watermill and running a deep sea cable underground to a dynamo that fed enough light bulbs for an evening's studying.

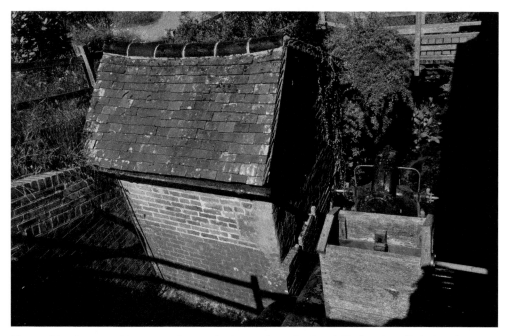

The turbine house at Batemans, Burwash, from where Rudyard Kipling installed electric power up to his house via a dynamo.

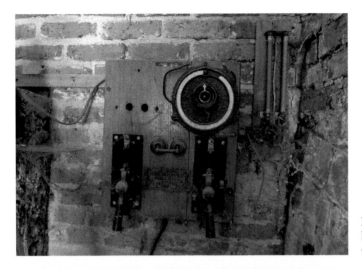

Kipling's original supply board, now missing its voltmeter. (David Vaughan)

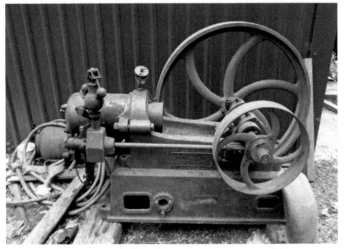

Kipling's dynamo was driven by this Hornsby-Akroyd 3.5 hp engine, No. 6038. It is now missing its fuel pump and in the care of the Claude Jessett Trust at Hadlow Down. (David Vaughan)

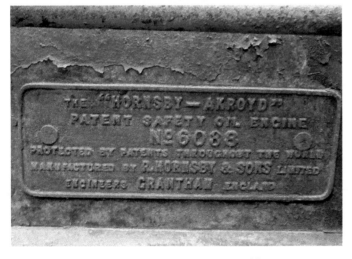

The Hornsby-Akroyd engine workplate. (David Vaughan)

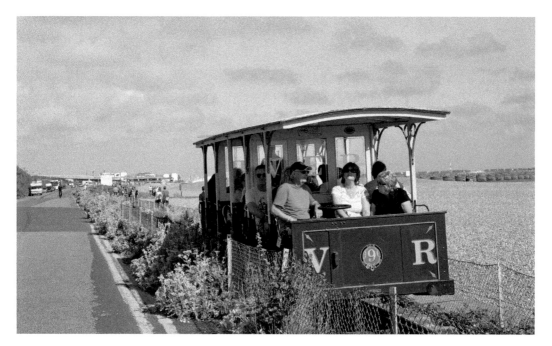

Although intended for pleasure rather than industry, Magnus Volk built Britain's first public electric railway on Brighton seafront in 1883 after bringing electricity to council buildings in the early 1880s.

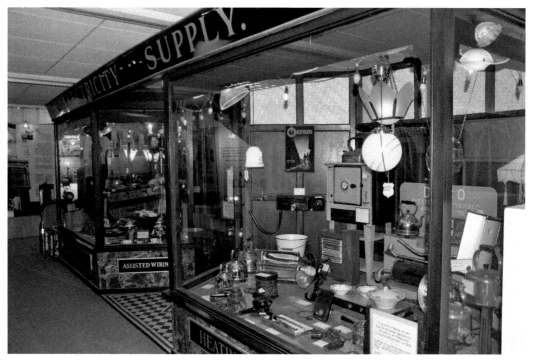

A 1930s domestic electricity showroom, recreated at Amberley Museum.

Gas

Heathfield, Natural Gas

Natural gas was discovered in 1896 by railway workers at the entrance to Heathfield railway tunnel while searching for better-quality water to supply their locomotives. 'Heathfield Gas' continued to illuminate the town's station until the 1930s. When reserves began to run low, it was decided to switch to town gas. A single standpipe is all that remains of this work, hidden among the trees near the bridge in Ghyll Road. TQ 581206.

The last remnant of the Heathfield natural gas project is this standpipe, which is adjacent to a footpath from Ghyll Road.

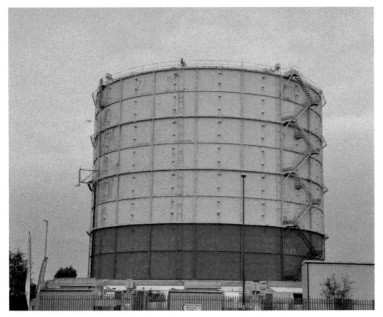

Gasholders were once a common sight in every town, but it is now more cost-effective to keep gas in pipes. This now disused example is in Littlehampton.

Water Supply

There are 143 village pumps listed in Sussex, according to the UK National Register (villagepumps.org), which served largely rural communities prior to the introduction of a mains water supply. Indeed, many villages were not served with mains water until the early twentieth century. The growing towns of the Sussex Weald and coastal communities brought increased demand for pure water, which was channelled from reservoirs via pumping stations – some of which were quite grand in their construction, such as the two surviving 'Cathedrals of Steam' that were built to serve Brighton and Hastings. Disposal is also important and public tours can be made of the Victorian sewers in Brighton at low tide on selected dates. Visit Southern Water's website for more details.

Brede Pumping Station

A restored 410 hp Tangye of Birmingham triple-expansion steam pumping engine (one of two original to the site) is housed in the waterworks built by the Hastings Corporation to serve the town's growing needs in 1904. Joined in 1940 by a third pump, manufactured by Worthington Simpson of Newark, water was drawn from large wells beneath the River Brede, which was then purified and pumped into reservoirs above Hastings for distribution by gravity. West of Brede Hill on the A28, the pumping station is open on the first Saturday in the month and on Bank Holiday Mondays. TQ 814178.

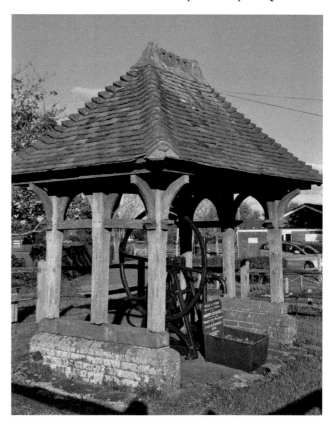

Of the 143 parish water pumps still to be found in Sussex, the pump at Ringmer, erected in 1883, is one of the grandest.

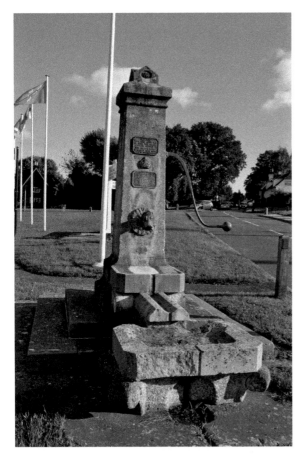

Left: Newick's village pump was erected in 1897 to commemorate Queen Victoria's Jubilee.

Below: Brede Pumping Station, which was built to serve Hastings' growing needs in 1904.

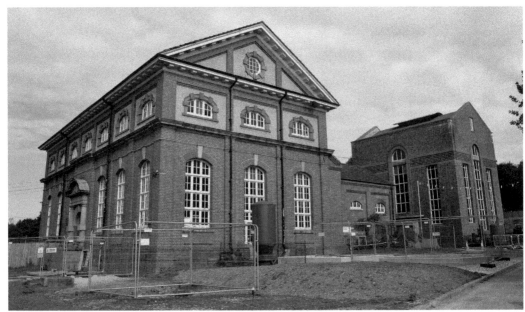

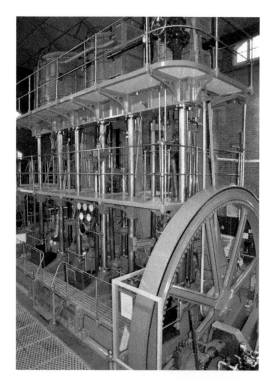

A restored Tangye of Birmingham triple-expansion steam pumping engine at Brede.

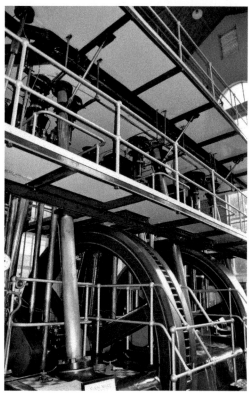

These Worthington-Simpson of Newark pumping engines were added to Brede's output in 1940.

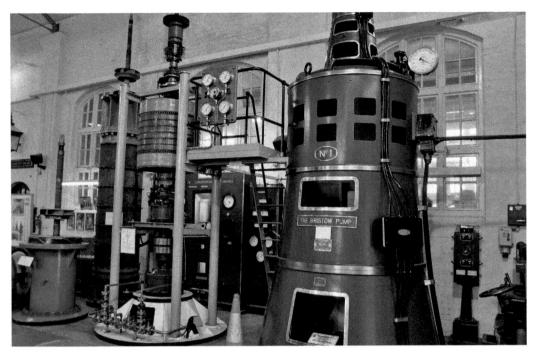

A display of items in Brede Pumping Station, including the Bristow Pump, which was rescued from Balsdean Pumping Station, near Rottingdean.

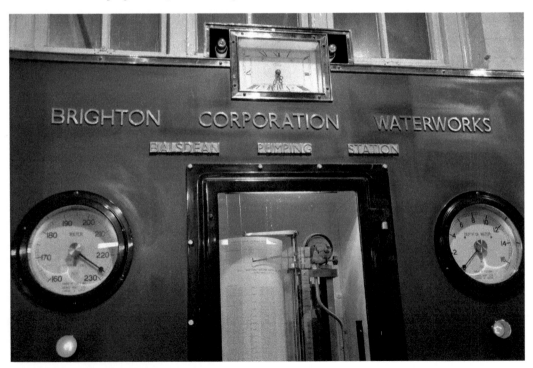

The art deco fascia rescued from Balsdean.

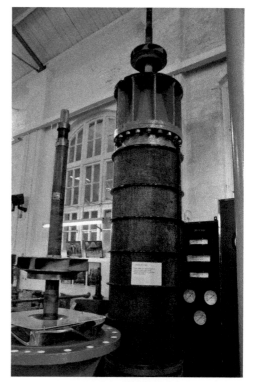

Right: The water intake strainer from Balsdean.

Below: An early US-built Ingersoll-Sergeant pump engine on display at Brede.

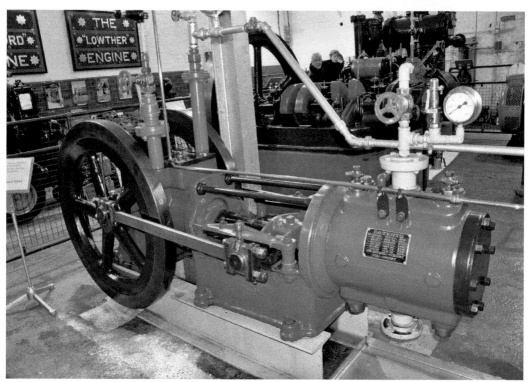

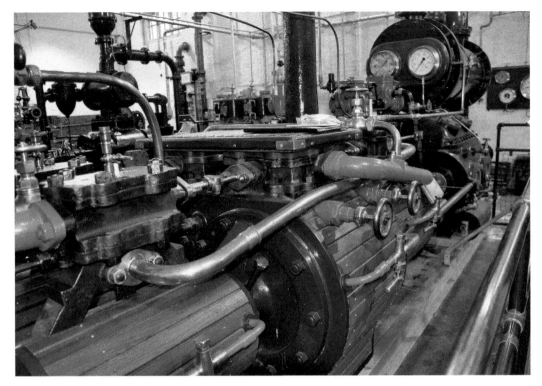

A James Simpson horizontal duplex engine in the former boiler house at Brede.

Coultershaw Water Pump

The original 1782 beam pump installed by George Wyndham, 3rd Earl of Egremont, to pump water from the River Rother to Petworth House and town, which was uphill, some 1.5 miles distant. A breast shot wheel, installed in the mid-nineteenth century by Robert Chorley of Cocking Ironworks, produced about 3 hp, and the machinery is now protected within a re-sited wagon shed from Goodwood. An Archimedes screw turbine was installed in one of the adjacent former sluices in 2012, generating electricity from a sustainable source. South of Petworth on the A283, the pump is open from Easter to October on the first and third Sundays of the month. SU 972194.

Foredown Tower, Portslade

A brick-built water tower of 1909 to service an isolation hospital, it was the last structure standing when the hospital was demolished in the late 1980s. The tower housed an iron header tank by J. Every of Lewes, dated from 1909. Since closure, and having been given over to community use, it now houses the largest operational camera obscura in the South East, where visitors can observe the skies by prior appointment. TQ 257070.

Goldstone Pumping Station, Hove

Located just off Nevill Road, Goldstone Pumping Station is a structure comprising two engine halls connected by a boiler house dating from the 1860s. The whole structure is finished in impressive polychromatic brickwork. One of the nationwide schemes to be designed by Thomas Hawksley, it opened in 1866 and served Brighton and Hove

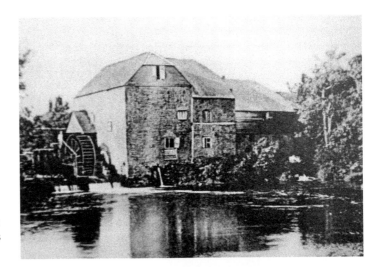

Coultershaw Mill and beam pump, built to pump water to Petworth from the River Rother, is seen in its heyday.

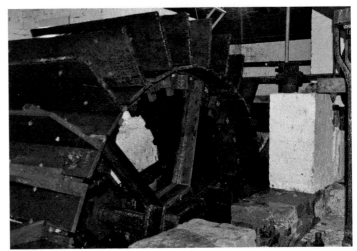

The working waterwheel at Coultershaw.

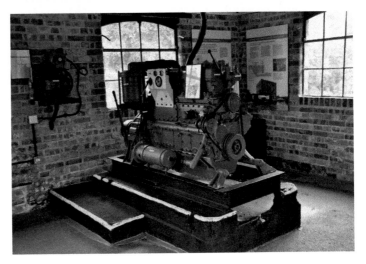

A Leyland diesel engine – the last example used to provide power to Coultershaw Mill.

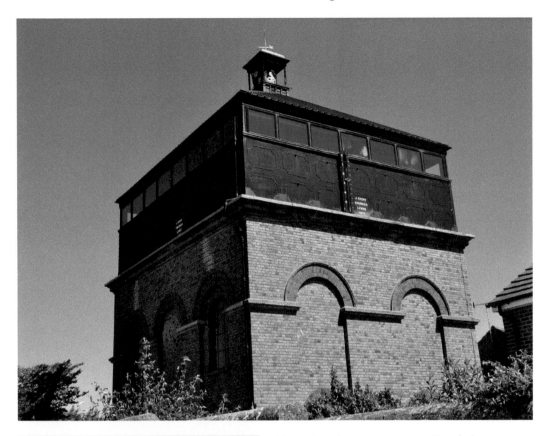

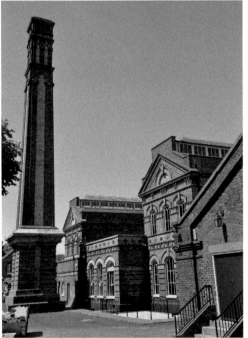

Above: Foredown water tower, Portslade, was built to serve a now demolished isolation hospital.

Left: Goldstone Pumping Station, Hove, was built on a grand scale in the 1860s.

until 1952. The original 130 hp beam engine was replaced in 1876 by an Easton & Anderson compound beam engine of 250 hp. Branded 'The British Engineerium' as a steam museum, the site changed ownership in May 2006, with the assets being sold to a local businessman. Having spent millions of pounds on restoration of the engines and infrastructure, the whole site was being offered for sale in early 2018. TQ 286066.

Water Cistern, Rye

A brick tower with a truncated dome, built in the 1730s to help improve the town's supply, the structure is situated in the corner of St Mary's churchyard. The oval-shaped brick cistern itself is below ground, holding around 20,000 gallons. TQ 922203.

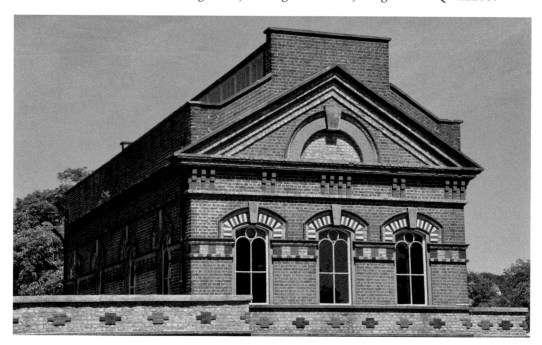

Above: Brick detail of the Goldstone Pumping Station.

Right: The Rye Water Cistern and tower.

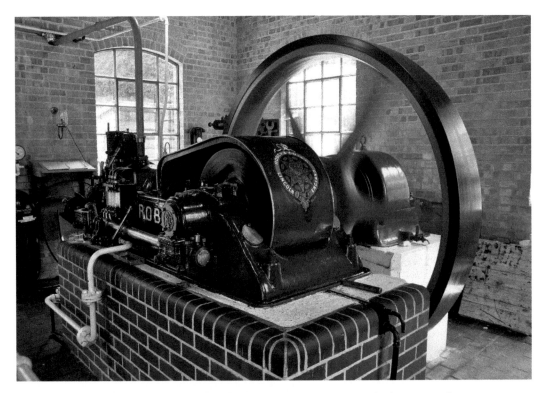

A Robey of Lincoln horizontal single-cylinder engine, No. 4523, which was used to pump Littlehampton's sewage up from the sewers to the sea. It is now at Amberley Museum.

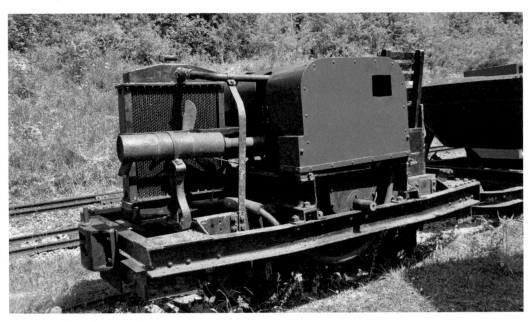

A 1936 Hibberd diesel shunter, which used to be based at Chichester Sewage Works and is now preserved at Amberley.

Chapter 9

Warehouses, Works and Granaries

Chichester, Granary

Brick-built granaries on Baffins Lane, Chichester, date from the 1870s and have now been converted to offices. SU 863046.

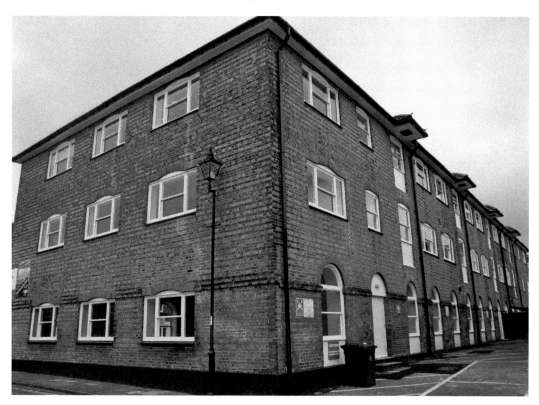

The imposing brick-built granaries on Baffins Lane in Chichester have been refurbished for letting as office space.

Lewes, West Street
A former candle-making works of red brick with its chimney still in situ, and then a needle-making works producing hypodermic needles, the structure is now branded 'Needlemakers Craft Centre' and supports small craft outlets. TQ 415102.

Rye, Corn Warehouse
An imposing nineteenth-century, three-storey brick building on Ferry Road, next to the level crossing, with sack hoist wheel on the west side, it is now the Granary Snooker Club. TQ 918204.

Rye, The Strand
A series of timber-boarded warehouses on a brick base, which were built in the eighteenth and early nineteenth century, when trade vessels came up the River Rother to the town quay. The buildings have been preserved and converted to various uses, including now acting as the town's tourist office. TQ 918202.

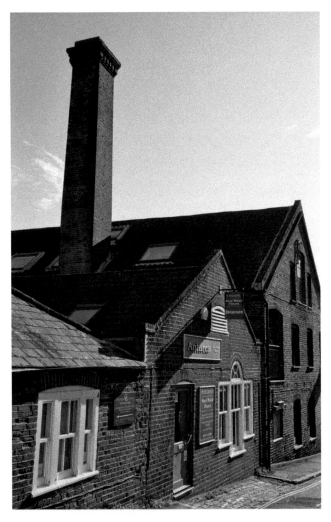

An amazing survivor with its brick chimney, the former candle factory, then hypodermic needle works, on West Street, Lewes. It is now the 'Needlemakers' craft centre.

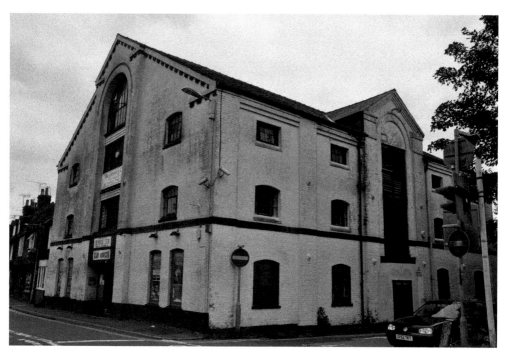

The nineteenth-century corn warehouse next to the level crossing in Ferry Road, Rye. It is now 'The Granary' snooker club.

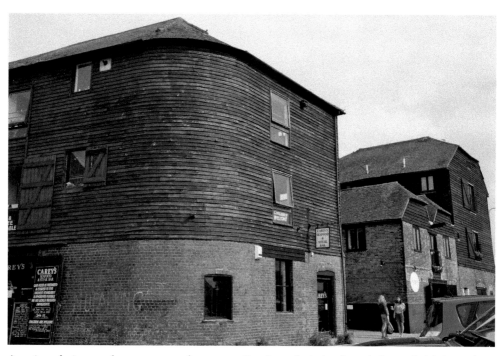

A series of nineteenth-century warehouses on Rye Strand, timber-boarded on a brick base, from the days when boats came right up to the town.

Chapter 10

Ports and Fishing

'Sussex by the Sea' – the importance of the sea to Sussex has been crucial through its history, and its proximity to the continent has brought forth invaders of all sorts over thousands of years, including the most important and famous invasion of 1066. Harbours kept the county supplied with goods such as building materials and foodstuffs, and provided employment to boatbuilders and sailors. Shoreham is the only Sussex port mentioned in a seventeenth-century survey of shipbuilding. Fishing boats could be found on the beaches throughout the county and fishing smacks of Sussex oak were built on the river banks at Rye Strand until the beginning of the twentieth century.

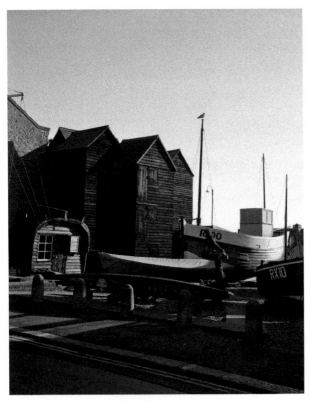

The distinctive fishermen's net huts on The Stade in Hastings Old Town.

The history of The Watch House at Rye Harbour is sketchy, but it has served as a lifeboat station during its life.

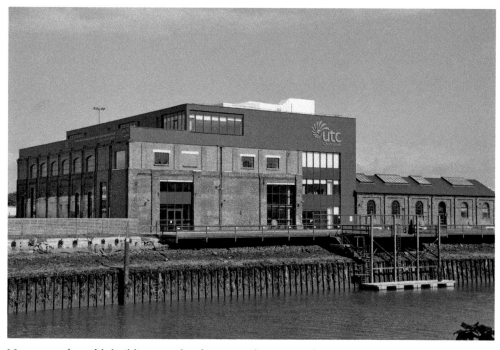

New uses for old buildings – the former railway-owned marine engineering workshop at Newhaven is now a technical college.

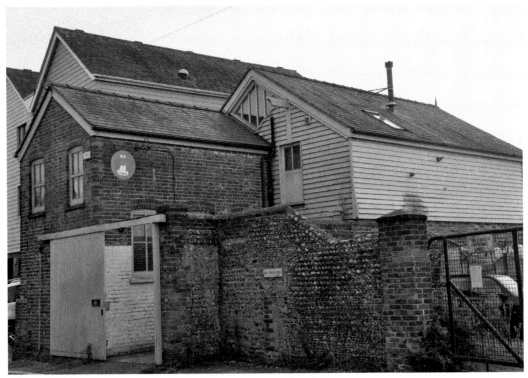

Former harbourside workshops and sawmill on Ferry Road, Littlehampton.

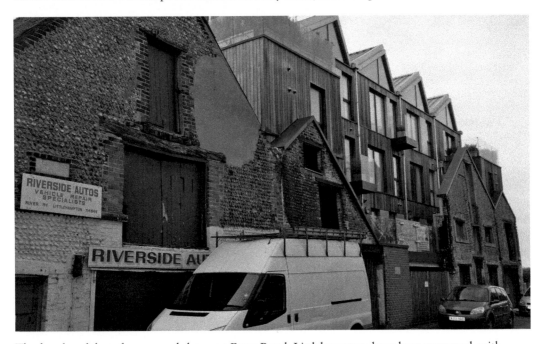

The facades of these former workshops on Ferry Road, Littlehampton, have been preserved, with modern development having taken place behind.

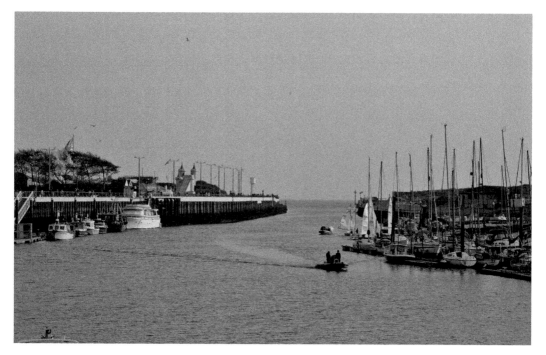

The mouth of the River Arun at Littlehampton – an important former port for goods and early cross-Channel boats.

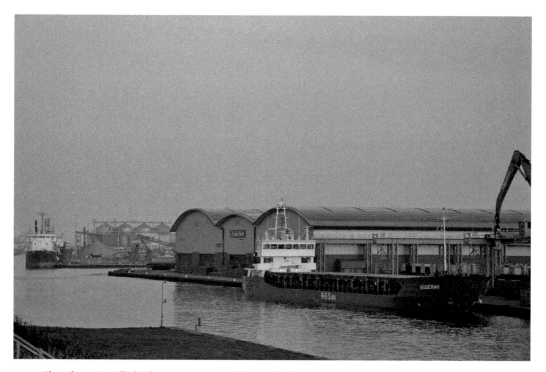

Shoreham is still the busiest commercial port in Sussex.

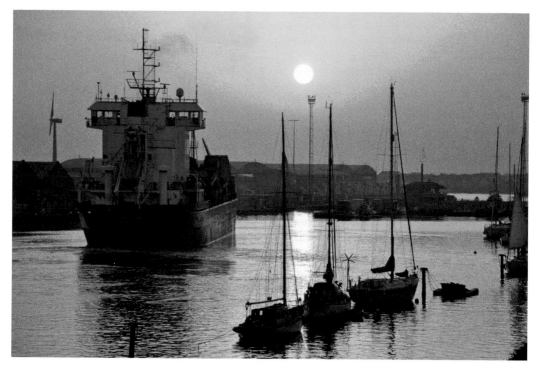

The dredger *Sand Heron* awaits permission to leave the port of Shoreham.

Important medieval harbours in Sussex once included Chichester, Shoreham, Seaford, Rye and Winchelsea. Pevensey was already silting up and most of the others followed.

Chichester had finished being a commercial port by the end of the Second World War, but trade had already dropped steadily on the arrival of the Brighton to Portsmouth railway. The harbour area is now given over to the mooring of leisure craft.

The catalyst for the decline of Littlehampton as a port came with the decision by the London, Brighton & South Coast Railway to withdraw cross-Channel steamers in 1882, favouring the newly cut harbour at Meeching (the 'new haven'), which it owned. This was compounded by the decline in the need for wooden sailing vessels built at Littlehampton's main shipyard.

Newhaven remains as the port for the Dieppe ferry route, while Shoreham retains its position as the county's busiest commercial port.

Chapter 11

Transporting the Goods

Canals and Navigations

Sussex may not have had the great swathes of inland waterways of the scale that connected the large industrial towns and ports of the north of England, but the short heyday of the cuts and navigations in Sussex brought a means of carrying coal, aggregates for road improvements, manure, chalk and lime that can be considered an improvement when compared with the poor condition of the roads. The canals, of course, were in turn soon superseded by the arrival of the railway.

Adur Navigation (Baybridge)

A short stretch of canal of 3.5 miles in length, it was opened in 1826 (and abandoned by 1875) with the aim of improving access for boats from next to the Horsham to Worthing Turnpike (now A24) to Bines Bridge on the River Adur, which can be seen beside the B2135 near Partridge Green.

The Portsmouth & Arundel Canal

Built in 1823 by the Portsmouth & Arundel Navigation Company, and ceasing operation in 1855, it consisted of three sections with the aim of securing an inland route for traffic between the towns without heading into the Channel. Little remains of the Ford to Hunston section. Birdham Lock is visible on the Birdham to Hunston section (SU 826012). The Chichester Canal from Birdham to Chichester is navigable and was once part of the P&A Canal.

The Rother Navigation

Construction started in 1791 and the navigation opened in 1793 to link Petworth and Midhurst with the sea via the River Arun. Engineer William Jessop surveyed the River Rother for the 3rd Earl of Egremont, with 2 miles of cuts on an improved widened 12-mile navigation and eight locks. The heyday of goods barges on the route was from 1823 until 1859, and it was abandoned in 1888. TQ 033182 to SU 887213.

The Upper Ouse Navigation

The tidal Sussex Ouse, south of Lewes and down to Newhaven, had long been used by commercial vessels, but William Jessop was appointed to survey the Upper Ouse north of Lewes in 1787 with a view to extending navigation, initially to Slaugham,

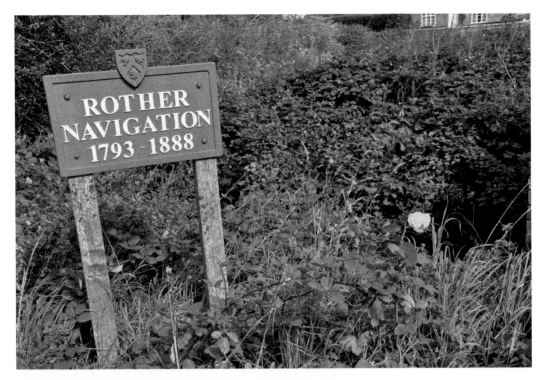

This signpost recalls the Rother Navigation at the overgrown Coultishaw Lock, south of Petworth.

The former lock walls at Coultishaw on the Rother Navigation.

which was never reached. The Upper Ouse Navigation Act was passed and construction commenced – with completion to Upper Rylands Bridge in 1812, near the Ouse Valley Viaduct on the London to Brighton railway line. Indeed, the 11 million bricks used to construct the viaduct in 1841 were transported via the navigation. The 22-mile route featured nineteen locks and a ¾-mile spur to Shortbridge via a wharf at Maresfield. Commercial activity north of Lewes had ceased by the 1860s, but the tidal stretch south of the town saw boats until the 1950s. Most of the locks are still extant although slowly deteriorating. Volunteers of the Sussex Ouse Restoration Trust work to conserve the structures of the navigation.

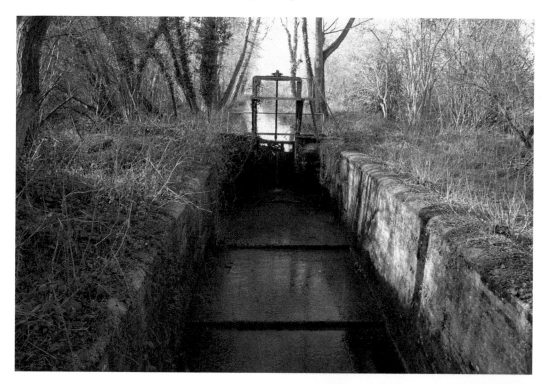

Above: One of the most complete lock chambers to survive on the Upper Ouse Navigation is at Bacon Wish, which is one lock upstream from Sheffield Bridge on the A275. It opened in 1798 and closed in 1868. (Phil Barnes)

Right: The last surviving farmers' occupation bridge over the Upper Ouse at Bacon Wish Lock. (Phil Barnes)

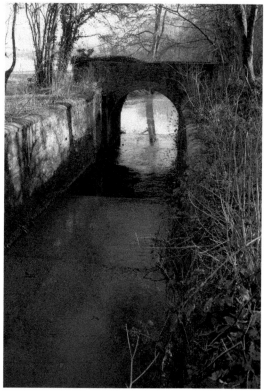

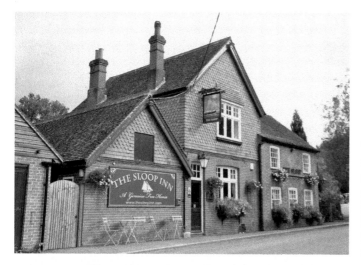

When commercial traffic on the Upper Ouse arrived, so did public houses to serve the needs of the bargemen, such as The Sloop Inn at Freshfield (pictured) and The Anchor at Barcombe.

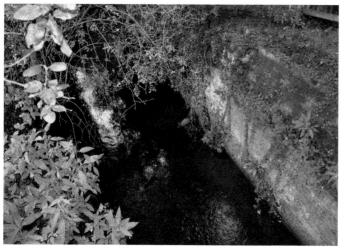

With the main watercourse having now been diverted, Freshfield Lock chamber, situated close to The Sloop Inn, is remarkably complete.

The end of the Upper Ouse Navigation was at Upper Ryelands Bridge, where these wharf cottages survive on the Balcombe to Haywards Heath road.

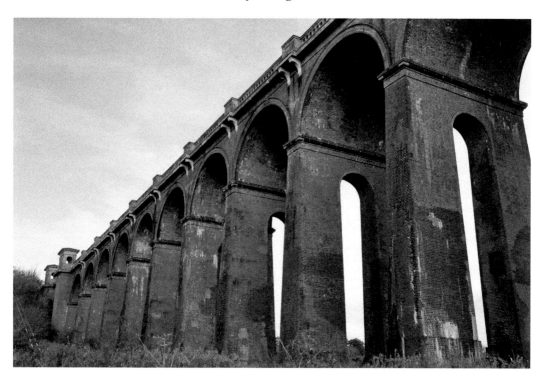

The 11 million bricks used to construct the Ouse Valley Viaduct on the main London to Brighton railway in 1841 were transported via the navigation. The bricks variously came up river from the Netherlands, Belgium or Piddinghoe, depending on your reference source.

A restored and navigable section of the Wey & Arun Canal.

Royal Military Canal
Constructed in 1806 by consulting engineer John Rennie as a coastal defence against possible invasion during the Napoleonic Wars, the 28-mile canal runs from Hythe in Kent and into Sussex, ending at Iden Lock (TQ 936244). A second, smaller section runs wholly in Sussex from Winchelsea (TQ 908175) to Cliff End (TQ 886129).

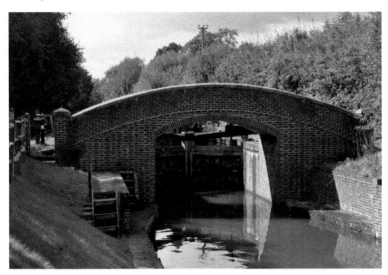

Left: The restored lock at Loxwood on the Wey & Arun Canal.

Below: The Wey & Arun Canal Trust's narrow boat *Zachariah Keppel* exits Loxwood Lock with a tour party.

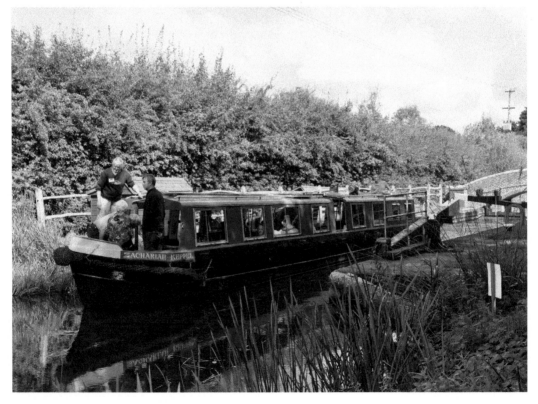

Wey & Arun Junction Canal

From Shalford on the River Wey in Surrey (and on to the River Thames) down to Pallingham Lock at the River Arun (and on to the sea at Littlehampton), 23 miles of canal were opened in 1816. With twenty-six locks, and engineered by William Jessop's son Josias, the canal provided an efficient route from London to Portsmouth to carry goods supplying the dockyards. The canal lasted commercially for just over fifty years. The Wey & Arun Canal Trust was formed in 1970 to restore 'London's Lost Route to the Sea' as an extremely long-term project. Volunteers have so far restored twenty-three bridges and half of the twenty-six locks. The Trust's information and visitor centre is located adjacent to the Onslow Arms on the navigation at Loxwood (TQ 41311), and the Trust's boats give public trips from the adjacent jetty south to Drungewick and north to Brewhurst.

Railways

Purpose-built goods sheds were once a common sight on our railways, but when road transport improved so that it could take goods from door to door, their days were numbered from the mid-1960s. Commuters' car parks and retail or housing developments have swallowed disused goods sidings and the sheds with them, although there are still some remarkable twenty-first-century survivors.

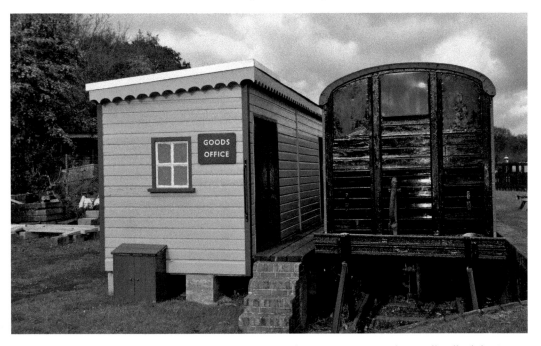

The London, Brighton & South Coast Railway, whose empire covered virtually all of the Sussex routes, built these simple timber 'goods lock-ups' in their goods yards at all but the major stations. This preserved example is at Kingscote, on the Bluebell Railway, having been moved by the preservation society from its original location of Horsted Keynes (two stations south), where it stood in the way of workshop development. A further example from Three Bridges stands in the garden at Kingscote, and is now used by the team that maintains the station.

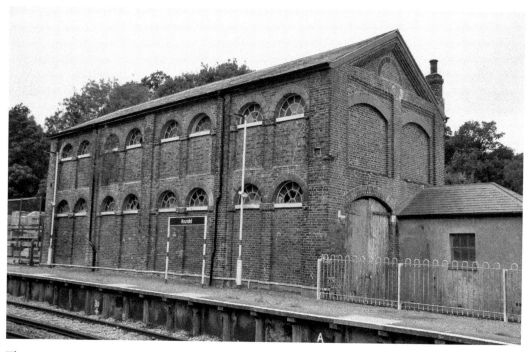

The two-storey brick goods shed at Arundel is a particularly fine survivor from the days of transporting goods by rail.

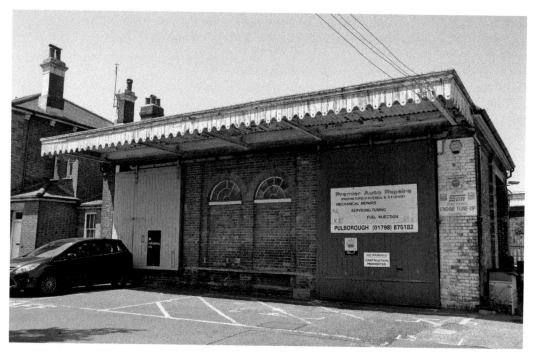

Pulborough goods shed is a remarkable survivor, sited at what was once an important junction station for the line to Petworth and Midhurst.

Bibliography

Austen, B., Cox, D. and Upton, J., *Sussex Industrial Archaeology: A Field Guide* (Chichester: Phillimore & Co. Ltd, 1985).

Beswick, M., *Brickmaking in Sussex* (Midhurst: Middleton Press, 1993).

Cleere, H., and Crossley, D., *The Iron Industry of the Weald* (Merton: Priory Press, 1995).

Finch, M. L., *Windmills at Work in East Sussex* (Seaford: SB Publications, 2004).

Gregory, F. and Martin, R., *Sussex Watermills* (Seaford: SB Publications, 1977).

Harries, D., *Maritime Sussex* (Seaford: SB Publications, 1997).

Oppitz, L., *Sussex Railways Remembered* (Newbury: Countryside Books, 1987).

Wikeley, N. and Middleton, J., *Railway Stations – Southern Region* (Seaton: Peco Publications, 1971).

Further Reading

The annual journal and quarterly newsletters of the Sussex Industrial Archaeology Society are recommended for those seeking further information to sites of interest, both historic and surviving. Details can be obtained from the Membership Secretary: Peter Holtham, 12 St Helens Crescent, Hove, BN3 8EP. Email: pandjholtham@virginmedia.com

Websites

The following websites were found to be useful as a starting point for further study of the industrial heritage of Sussex:

Breweries
http:/www.breweryhistory.com

Canals
http:/www.sxouse.org.uk
http://www.weyarun.org.uk

General
http:/www.sussexias.co.uk
http:/www.derelictplaces.co.uk
http:/www.en.wikipedia.org

Hammer Ponds
http:/www.hammerpond.org.uk

Village Water Pumps
http:/www.villagepumps.org.uk

Waterwheels and Windmills
http:/sussexmillsgroup.org.uk